RATHMINES

RATHMINES

MAURICE CURTIS

The
History
Press
Ireland

First published 2011

The History Press Ireland
119 Lower Baggot Street
Dublin 2, Ireland
www.thehistorypress.ie

British Library Cataloguing in Publication Data.
A catalogue record for this book is available from the British Library.

ISBN 978 1 84588 704 9

Typesetting and origination by The History Press
Printed in Great Britain

Contents

Acknowledgements

This book might not have been written except for the groundbreaking and sterling work of the late Deirdre Kelly, local historian *par excellence* and author of *Four Roads to Dublin*. And likewise with Éamonn MacThomáis, a former Rathmines resident, whose reminiscences on Dublin in the 'rare aul times' were, and continue to be, an inspiration. We also owe a debt of gratitude to Séamus O'Maitiú and his book *Dublin's Suburban Towns 1834-1930*. Rathmines Library nourished in me a love of books since I first started using the Children's Library, when it was upstairs. And years later, its Reading Room was a particular comfort and ally during my student days. Many thanks to all the staff of Dublin City Libraries and Archives (especially Dr Máire Kennedy and Hugh Comerford), and in particular the staff of Rathmines Library. Thanks to the National Library of Ireland (NLI), the Dublin Photographic Archives, the Irish Georgian Society, the Irish Architectural Archive, Heritage Ireland, Waterways Ireland, the OPW, Flickr, the Irish Historical Picture Company and the Irish Film Archive.

Dublin City Council, and in particular its Dublin.ie Rathmines Forum, was a great help. The Rathmines and Ranelagh Historical Society, the Harold's Cross History Society, and the Rathmines Heritage Group were fountains of information. The R&R Musical Society, which celebrates its centenary in 2013, was a beacon of light. Thanks to George P. Kearns for his photos and reminiscences on 'The Prinner' cinema. Bob Young (a.k.a. 'Bongo'), a former resident of Mount Pleasant Buildings, was a mine of information. And many thanks to Ann Cahalan for her photo skills. Also, 'Damntheweather' and 'Mountallant' of the Dublin.ie Rathmines Forum. In particular the former for photographs, reminiscences and willingness to be of every assistance. 'Damntheweather' is of immeasurable help to everyone and everybody interested in local history.

The suggestions of Murrough MacDevitt of the Leinster Cricket Club were helpful. The St Mary's Rugby Club, long associated with St Mary's College on Rathmines Road, has an honoured place in the history of Irish and international rugby. In the history of bowling in Ireland, the Kenilworth Bowling Club at Grosvenor Square has been very influential.

The National Archives has an unrivalled collection of material. RTÉ Stills Library has some wonderful photos, as does the Dublin City Council's Gilbert Collection in Pearse Street. The National Library's Lawrence Collection, which shows the character

of Irish towns and villages around 1880 to 1910, was unique and valuable. Ranelagh Village History Society, the Rathmines Antiquarian Society, and the Rathmines & Harold's Cross Antiquarian Society were very helpful. Thanks again to MC's FotoFinish for retrieving many photographs long forgotten, to Whyte's, Adam's, Howth Transport Museum, the Old Dublin Society, the National Gallery of Ireland and the National Gallery of Australia. And thanks too to Glasnevin and Mount Jerome Cemeteries. In the latter, many former residents of Rathmines now reside in peace.

Thanks to Fr John Galvin, Fr Richard Sheehy and the Parish Council of Rathmines Catholic church and to the Holy Trinity church and Grosvenor Road Baptist church – all were very helpful. A special thanks to Dr Tom Harris, that most wonderful and gifted teacher in the Pre-University Irish and English Departments of Rathmines College – truly a living legend! *Buíochas le Dia*! It is widely thought that, should he ever die, former students will recognise his benign ghost as it traverses Rathmines Road, adjacent to his statue.

Particular thanks also to Ronan Colgan and Beth Amphlett of The History Press for constant advice and encouragement. Also, June and Nuala O'Reilly of the Business Depot (formerly of Rathmines and now on Harold's Cross Road) performed very many miracles with the photographs – my deepest gratitude. It is reputed that June can walk on water! Tom Cantwell of Leinster Road was of great help with his reminiscences. Gratitude also to John Byrne of Politico.ie for his interview with Mike Murphy.

Particular thanks also to long-time Rathmines resident, Councillor Mary Freehill, for her commitment and tireless endeavours over the years for the people of Rathmines, Harold's Cross and the surrounding area.

And grateful thanks to my parents for deciding to live in Rathmines, thus ensuring that Leinster Road and the surrounding area would have a lasting impression and influence on me. Finally, a very special thanks to Mercedes and Leesha, who (still) have to put up with me!

Rathmines in Irish History

1000: Celtic era and early Christian period: Rath Maonais (Ringfort of Rathmines). Cuala and the Slí Cualann route out of Dublin. Parishes of St Kevin and St Patrick.

1169: Coming of Normans. De Meones family settled in the area. Beginning of civic and commercial centre.

1209: Massacre of Cullenswood. O'Toole and O'Byrne Clans of Wicklow assert their influence over Dublin. Extension of English rule delayed by centuries.

1317: Invasion of Dublin by Edward Bruce. Dublin not safe from Wicklow Clans for centuries.

1492: The Pale. English rule limited to Dublin and parts of Kildare, Meath, and Louth.

1649: Battle of Rathmines. Cromwellian invasion of Ireland facilitated.

1782: Grattan's Parliament. Henry Grattan and Irish legislative independence for two decades.

1803: Robert Emmet and the abortive Rising.

1829: The Repeal Association and the achievement of Catholic Emancipation.

1847: Post-Famine era, the Ascendancy and the establishment of the Rathmines Township.

1848: The Young Ireland movement. John Mitchell and John O'Leary.

1867: The Fenian Rising. James Stephens.

1900: The Celtic Revival. Yeats, Joyce and Osborne Families.

1916: The 1916 Rising. Grace Gifford and Joseph Mary Plunkett. Francis Sheehy-Skeffington. Cathal Brugha.

1917: Elections for an independent Irish Parliament (Dáil). Countess Markievicz makes history.

1919-21: War of Independence. Michael Collins, Richard Mulcahy.

1922: Independence and the New Ireland. Archbishop John Charles McQuaid, Alife Byrne, John Costello, Seán Lemass, Garrett Fitzgerald.

1932: Eucharistic Congress. Social and political change. Censorship, changing cultural and social values, strikes, politics.

Introduction

THROUGH THE CORRIDORS OF TIME

Rathmines is full of stories and memories. Each one of us who grew up in the area or spent some time there will have our own reminiscences. Flat-dwellers who came from the four corners of Ireland will doubtlessly have many stories to tell. Former youngsters will recall playing amidst the ruins of the declining splendour of 'Lordy's', the former home of the Lord and Lady Longford on Leinster Road, before it was requisitioned by developers, or 'boxing the fox' in many of the local orchards. One of the Doran brothers of the famous Doran's barber shop on Castlewood Avenue, recalled regularly seeing former Taoiseach Séan Lemass strolling along Castlewood Avenue from his home on Palmerston Road, on his way to the Stella Cinema, on a Saturday night.

Cinemagoers would recall buying a couple of Orange Maids, or a packet of Sobraine black Russian cigarettes in Harvey's tobacconist next door, or perhaps five Woodbines. Other old shops include Dorney's, Mahon's Dairy, Shaw's Hardware (and of course Lenihan's Hardware, which is still going strong), Miss Doorly's sweet shop and Craddock's Newsagent, opposite the Garda station. Nolan's Butchers (1936) is still going strong, nearly eighty years after they opened shop. An original messenger-boy's bike adorns the shop window. And on a Saturday evening there would be queues of people waiting outside Clegg's on Lower Rathmines for their shoe repairs so they could be well shod for Sunday Mass. Somebody else recalls the famous disco in the Leinster Cricket Club.

People still talk about the Stella and the Princess cinemas, and the nearby Red Shoes café that used to only open in the evenings. The Red Shoes was in Swanville, just around the corner from the Stella. There is still a secret passage that leads from here to Prince Arthur Terrace and the back of Leinster Square, beloved by adventurous children. Another café was the Cope, with its jukebox. The Rathmines Inn, Slattery's (with its unique snug), Rody Boland's, the Corrigan's/Mount Pleasant Inn, the Grove Inn, O'Byrne's (now Grace's) and Madigan's pubs, amongst others, are fondly remembered. And not forgetting Deveney's, still in business since 1910. Fothergill's bakery is also still going strong, as is Lawlor's butchers, where you will often see a queue for its fine meats.

On the subject of pubs, many's the great session of jazz and blues in Slattery's, or tradional music around the corner in Grace's. We still remember the flamenco guitarist 'Angel' and electric blues band 'John the Revelator'! In Slattery's there is always banter and a good laugh to be found. It has a genuine ambience and is a real traditional pub.

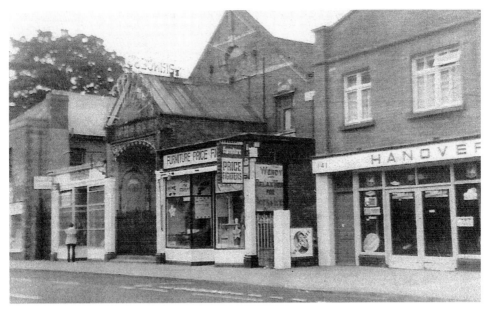

View of Rathmines, c. 1915. The home of the famous Princess cinema is located at the near right. Known by all and sundry as 'The Prinner' it finally closed on 2 July 1960. George P. Kearns worked there during his teenage years. He launched his book, The Prinner *in Rathmines Library in 2005 and it quickly sold out. The pages of* The Prinner *also record the history of the Stella Rathmines, the Classic Cinema Terenure, the Kenilworth/Classic in Harold's Cross, the Sundrive Cinema and Dublin's renowned Theatre Royal. Courtesy of IHPC/George P. Kearns.*

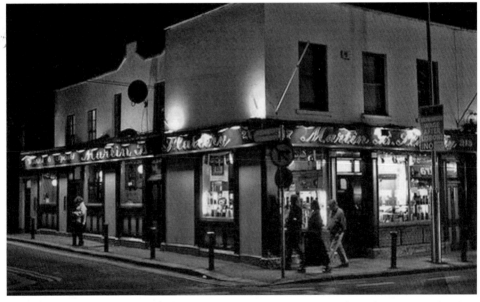

Slattery's Pub in Rathmines. The name and the landmark speaks for itself. A happy haunt for generations of residents, with great music sessions upstairs. The snug with its own front door leading on to the street is very quaint, and the confessional-type window for putting in orders for drinks had to be seen to be believed. Courtesy of Rathmines Heritage Society.

SNOOKER AND BEANBAGS

The Rathmines Snooker Hall on Upper Rathmines Road (now Zen Chinese Restaurant) evokes memories for many. They used to provide hot water for your instant cup of soup, so that you would not get too cold to play snooker. Two renowned snooker players were Stan the Man and Fast Eddie, who would take on any comers and clear the table before you could blink – and pocket the proceeds! It was rumoured that the great 'Hurricane' would think twice before challenging them on the green baize. A story doing the rounds at one time was of Stan the Man rushing to a snooker game in Rathmines on his Honda 90. They were the days when motorcycle helmets were not obligatory. Such was his hurry that his crown topper (wig) blew off and a bus drove over it. Stan the Man hopped off his bike, grabbed the battered wig, stuck it on his head and off he went for his game of snooker. His opponent lost the game, blaming the crooked wig on Stan the Man's head for distracting him! Not long afterwards, Stan the Man threw the wig away, and to this day sports a head as shiny as a snooker ball.

Many students and flat-dwellers will recall buying their first beanbag at the Blackberry Market, next door to Rathmines church. And not forgetting the Herman Wilkinson auction rooms, from where many a flat was furnished! It is the last of the traditional auction rooms, with a wide variety of specialist auctions, in addition to Dublin's famous weekly household and furniture event. These rooms have been a continuous feature of the Rathmines and Dublin commercial landscape since 1928. They hold between eighty and ninety auctions every year, more than any other auction rooms in Ireland.

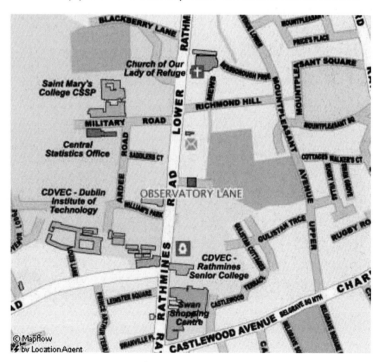

Map of Rathmines with some of the familiar place names. Courtesy of Rathmines Heritage Society.

Coming to Dublin from the country, the first view one would have of Rathmines would be the landmark green dome of the church. The 'bong, bong' of the Town Hall clock was also (and continues to be) a familiar and friendly sound.

THE LAMBERT CONNECTION AND 500 RUNS!

Many associated with the Leinster Cricket Club on Observatory Lane will have fond memories of epic games fought. Its pitch, originally laid down in 1928, is still considered to be one of the best in Ireland. The late Martin D. Burke, the club's longest-serving captain up until his ninety-sixth year, was an outstanding member of the all-conquering LCC sides of the 1930s, '40s and early 1950s. He was one of an elite group to have scored over 500 runs in a season. Another name which stands out, is that of Bob Lambert. It was a big occasion, the presentation of the Marchant Cup of 1921. His Honour, Judge Green, president of the Leinster Cricket Union, expressed his 'unbounded gratification that, after thirty years of strenuous cricket, his old friend was as virile and active as ever, and still the mainstay of the international XI'.

As Robert Hamilton Lambert moved to the platform to receive the trophy, tremendous applause welled up from the huge gathering, many of whom, now retired, had once played with and against the great man. Handing over the trophy, his Honour commented, 'Lambert's extraordinary batting average of 217 is a feat few will be capable of rivalling.'

THE LCC AND *ULYSSES*

Lambert's batting excited a pen of literary talent more distinguished even than Judge Green's. James Joyce was so taken by the power and beauty of his stroke play that he included him in a passage in *Ulysses*.

The majestic brilliance of Lambert's batting held everyone enthralled. Dashing and daring, a player of instant action, he was 'devastating at straight drives and hooks', according to a 1901 appreciation of his style and technique. Lambert had a personal following as warmly partisan as that of today's sportsmen. Right through his career he was the idol of the crowds who regarded him with as much as awe and admiration as they did that other great cricketer W.G. Grace. When he drove up to Leinster in his high trap, enthusiastic flocks crowded around in excited numbers. He was the big sporting celebrity of his time.

Many will also recall playing tennis in Grosvenor Square or playing in the oldest lawn bowling club in the Republic of Ireland, which is also in Grosvenor Square. It was founded in 1892 and is also the only club in the Republic with two bowling greens, one artificial and one grass.

ARMADA PAPERBACKS FOR BOYS AND GIRLS

The Banba Bookshop by the Town Hall was, for many years, a landmark bookshop trading in second-hand paperback books – a great boon to the voracious reading habits of children. 'Armada Paperbacks for Boys and Girls' was another expression for happiness. Across the road in the library, students toiled away for their exams in the quaint, upstairs Reading Room, whilst in the basement, readers were able to catch up on Irish and international news in the Newspaper Room, reminiscent of a bygone era.

Holyfield and Mount Pleasant Buildings were demolished in the 1970s, to be replaced by modern housing developments. The Tranquilla enclosed order convent on Upper Rathmines Road (with the nuns invisible behind closed curtains) evokes memories, as do Lee's Department Store, the H. Williams supermarket, and Findlater's shop (later Power's supermarket). When you ordered your groceries from Findlater's, or your meat from David Nolan's butcher shop across the road, or from any of the many local shops, the goods would be delivered to your door by a messenger boy on his bicycle, with the big wicker basket up front.

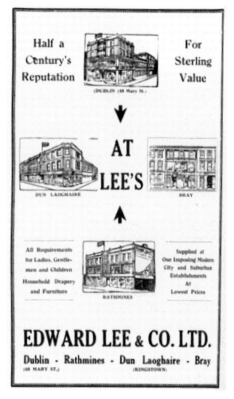

Advertisement for the famous Lee's of Rathmines and other branches. Lees opened a branch in Rathmines in 1911. Courtesy of *Irish Free State Handbook,* 1932.

OF LAUNDRIES AND HANDKERCHIEFS

Although the building is gone, save for the façade fronting a block of apartments, the staff of Kelso Laundry on Lower Rathmines Road are remembered by a tree (called the Handkerchief Tree) in nearby Harold's Cross Park, for their heroic and successful struggle for better working conditions in the 1940s. Some will recall the swastika-emblazoned laundry vans in the area. And there were also the Dartry Laundry vans.

The old swimming pool is now replaced with the new Swan Leisure Centre. The Swan Shopping Centre now has a new three-cinema complex built overhead. Swan Cinemas is the first in Dublin custom designed for digital cinema. Rathmines had been without a cinema since the closure of the Stella over five years ago. The entire Dublin 6 region has been underserved by a cinema since before the closure of the

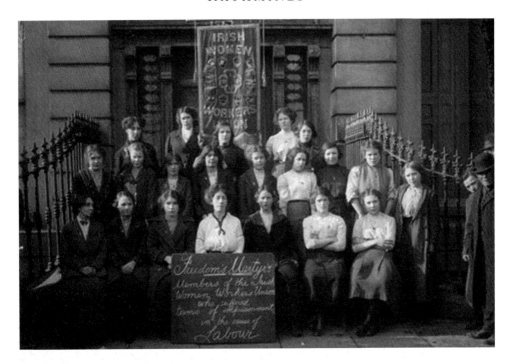

Classic Cinema in Harold's Cross (originally named The Kenilworth, although locals called it 'the Kenno'), in August 2003. The state-of-the-art Swan Cinemas will be an invaluable tool in revitalising the local area and helping to foster a community spirit.

A DOG'S LIFE

Dubray and Alan Hanna's bookshops are also favourites with the local residents. The friendly and unfailingly helpful staff makes visiting both bookshops a pleasure. Each has its own unique identity. The latter, a long-established and highly respected family business, has its own dog in residence to welcome browsers! Hanna's is a friendly, independent Irish store that has kept its own identity – certainly one to be celebrated.

The old College of Commerce is now a college of the Dublin Institute of Technology (DIT) and has expanded to include a School of Journalism. The *Rathmines Style Book* is a must for budding journalists. Well-known journalist and author Louis McRedmond became the first director of the course in journalism in Rathmines in 1970. The words 'The Rathmines Technical Institute' are still plainly visible on the Leinster Road side of the building, around the corner from the entrance to Rathmines Library, and it is now the home of the DIT College of Music. You will often hear the sweet tones of budding singers and musicians wafting out on a breeze from the top windows as you pass this fine building. St Mary's College, run by the Holy Ghost (now Spirit) Fathers, and St Louis Schools are full of memories for the many past pupils who passed through their gates.

Opposite: *The Irish Women's Workers Union, pictured c.1911, who were instrumental in the successful outcome of the Dublin laundry workers' strike of 1945. Kelso Laundry on Rathmines Road was one of the most important laundries in Dublin. In 1945, the laundry workers, worn out by all the overtime done during the war, voted for strike action to be taken. The workers went on strike for two weeks' paid holidays. The employers eventually backed down, and the October agreement laid down that 'all women workers employed in laundries operated by members of the Federation shall receive a fortnight's holidays, with pay, in the year 1946'. There is a tree and plaque in Harold's Cross Park commemorating the successful efforts of the striking Rathmines laundry workers.* Courtesy of NLI/HXHS.

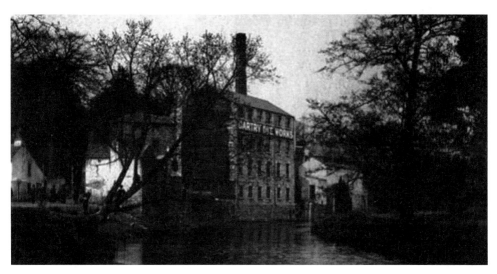

Dartry Dye Works, Upper Rathmines, c.1910. Courtesy of Dublin.ie.

Views from Portobello Bridge of South Richmond Street. Courtesy of Dublin.ie.

The Central Statistics Office occupies a large office building on Ardee Road, near the entrance to Cathal Brugha Barracks. An even larger complex, on Cowper Road, has for many years been the home The Mageough. The Mageough Home was founded in 1878, in accordance with the will of Miss Elizabeth Mageough, to provide accommodation for 'elderly ladies professing the Protestant faith'. The Mageough consists of thirty-five individual red-brick houses, available for residents in a very peaceful setting in extensive grounds. It has its own chapel. Like so many hidden places in Rathmines, one has to go searching to find this tranquil complex.

THE SPOTTY TUNNEL

Happy times for many are evoked by the bowls and tennis in Grosvenor Square, the cricket (and weekend discos) in the Leinster Cricket Club, the legendary St Mary's rugby team, basketball in the park on Upper Rathmines Road, and, for young children, the playgrounds in Belgrave Square, Palmerston Park, and the 'Spotty Tunnel' playground in Upper Rathmines.

Some will also remember the Childhood Museum opposite Palmerston Park, with its dollhouses. Tara's Palace is undoubtedly one of the world's most significant dollhouses. Sir Neville Wilkinson's celebrated Titania's Palace of 1907 inspired it. Meticulously constructed, it has taken over a decade to complete and work is still ongoing. Designed and built to one-twelfth scale, it encapsulates the grandeur and elegance of Ireland's three great eighteenth-century mansions: Castletown House, Leinster House and

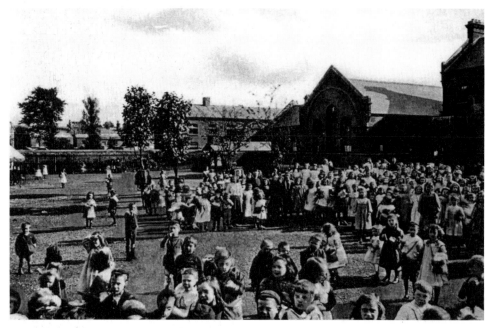

Children playing in St Mary's School playground, Rathmines in the early 1930s. Courtesy of IHPC.

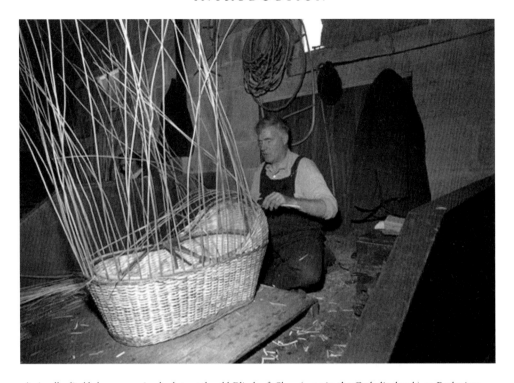

A visually disabled man weaving baskets at the old Blindcraft Shop (opposite the Catholic church) on Rathmines Road. Courtesy of RTÉ Stills Library.

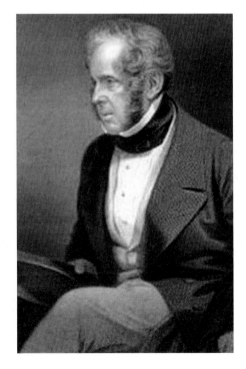

Lord Palmerston (Henry John Temple) (20 October 1784-18 October 1865), the third and last Viscount Palmerston, was a British Prime Minister and liberal politician. He was in government office almost continually from 1807 till his death in 1865. At the beginning of the eighteenth century, the Temple family, ennobled under the title of Palmerston, came into possession of Rathmines, and to this circumstance the use of the name Palmerston (and Temple and Cowper) in the present nomenclature of a great portion of the district is due. Courtesy of HXHS/Rathmines Heritage Society.

Carton. Paintings by leading Irish artists and miniature furnishing masterpieces adorn the state rooms and private apartments. The displays are augmented and supported by a collection of dolls, antique toys and other dollhouses, including Portobello (*c.* 1700),

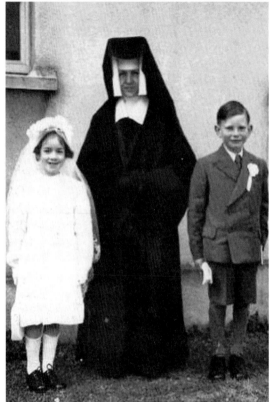

Rathmines children on their First Holy Communion in 1951, pictured with a nun in traditional habit. Courtesy of Bob Young/Dublin.ie/DCC.

Playing tennis at St Louis High School, Charleville Road, mid-1960s. A popular girls school with 600 pupils enrolled. There is also a primary school accessed via Louis Lane, off Leinster Road or via Williams Place behind the new Swan Leisure Centre. Courtesy of St Louis High School, Rathmines.

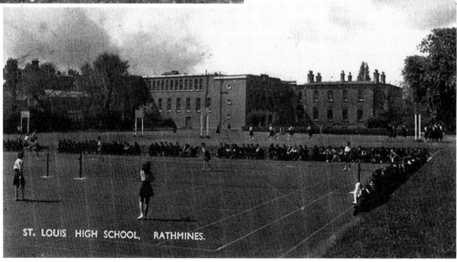

ST. LOUIS HIGH SCHOOL, RATHMINES.

one of the earliest surviving dollhouses from the collection of Vivien Green, together with a dollhouse from the family of Lady Wilde (Oscar's mother). Interestingly, the Wilde's family grave is in nearby Mount Jerome Cemetery.

THE RATHMINES RIOT

Doubtlessly, Rathmines forged and forges all kinds of memories for past and present residents. Everybody has his or her memories. Who recalls the riots in Rathmines in the mid-1930s, when CYMS activists clashed with those attending a Communist meeting in the Town Hall? It got huge coverage in the newspapers of the time.

And to a far lesser extent, the event years ago that saw the customers of Slattery's Pub dive for cover and witness a chair being flung through its window by a disgruntled passer-by. Or who recalls Thin Lizzy's Phil Lynott attending the College of Commerce? Or the trams going up and down Rathmines Road? Or the burning down of Rathmines Catholic church? Some might recall the familiar figure of Lord Longford, as he made his way down Leinster Road on his way to the Gate. Or the chain-smoking bespectacled Fr Michael Cleary, with the newspapers clasped under his arm as he sauntered around on a Sunday morning. More recently, the Festival Under the Clock is forging friendships and memories for many.

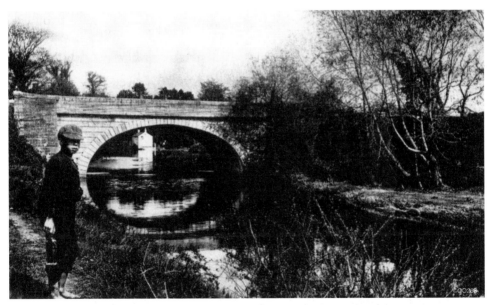

A barefoot boy fishes at Orwell Bridge, Rathmines at end of the nineteenth century. The River Swan, which flows under Rathmines, is a tributary of the Dodder River. Hurricane Charlie passed south of the country on 25 August 1986. In twenty-four hours, 200mm of rain poured down on Kippure Mountain while 100mm fell on Dublin, causing heavy river flooding, including the Dodder in many places, and hardship and loss were experienced. Courtesy of IHPC.

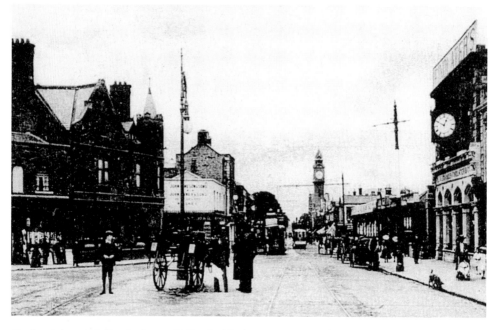

Roads and shops, including the famous Findlater's of Rathmines. Courtesy of IHPC.

CAKES, GUINNESS AND PRANKS

I wonder who remembers Ferguson's cake shop and tearooms, located where the Swan Centre now is. Although it was called Ferguson's, an Austrian family owned it. The Austrians were known for their cake-making and pastries at the time. Even then there were different nationalities living and working in Rathmines. The Guinness (of brewing fame) and Sisk (Ireland's largest construction company) families are also remembered by some of the older residents of Rathmines. Like many of the former residents of Rathmines, some of the Guinness family were buried in nearby Mount Jerome Cemetery, where their mausoleum may be seen. Some will remember pounding the barracks square on a Sunday morning with the 'Free Clothes Association', as the FCA part-time army was affectionately called.

We also recall RTÉ's Mike Murphy and his candid camera pranks around Rathmines and Harold's Cross, from 1979 to 1982. He disguised himself and tried to pull the wool over people's eyes by persuading them to let him into their houses, or to give him a loan of a bike or a car, or that he was someone of importance etc. All sorts of devilment, in fact. He grew up in the area and this doubtlessly inspired him to launch his brand of humour, *The Live Mike*, on the unsuspecting and at times horrified residents. The candid camera scenes invariably ended with the host saying 'I'm Mike Murphy from RTÉ', which virtually became a catchphrase. One senior citizen was heard to tell him, 'If ya don't get away from me, ye aul harebaiter, I'll blow your brains out with me brolly'! Another warned him, 'Get up the yard, there's a smell of Benjy off ya!'

*Early picture of RTÉ broadcaster
Mike Murphy, whose* The Live Mike
*television programme brought much mirth
to the people of Ireland. Many of the
programmes were filmed in the Rathmines
area and featured local residents.*
Courtesy of RTÉ Stills Library.

On another occasion, Murphy asked long-time resident of Rathmines (Neville Road and Cowper Village) Annie Kavanagh if 'he could go home with her'. 'Off with you,' she said, 'sure haven't I somebody already at home to look after' (her husband, Joe). Mrs Kavanagh herself went on to make history by being, at the age of 102, reputedly the oldest resident of Rathmines, of Dublin, and one of the oldest people in Ireland. She was still mobile at the age of 100 and was happy to receive a cheque from President Mary McAleese on reaching the centenary.

The following is a story told by Mike Murphy himself and it gives an interesting snapshot into another era and way of life:

> So anyway, I had to go to confession and I had a few goodies to tell because I wasn't the best behaved at a certain stage in my life. I decided that I better not go to my own parish where the priest would know me so I went down to Rathmines instead. At the time I had got on the radio alright – I was doing stuff in the evening on RTÉ. So I told the priest this whopper of a one that I had and he gave me absolution and 'God bless you'. I was just getting up to go and he said, 'Just a moment my son – that wouldn't be a familiar voice I hear?' So I froze. 'How do you mean, father?' He says, 'That wouldn't be Tony Lyons, the newsreader, would it?' I said, 'It would, father' … Then I had to go to confession on the other side of the church because I just told a lie.

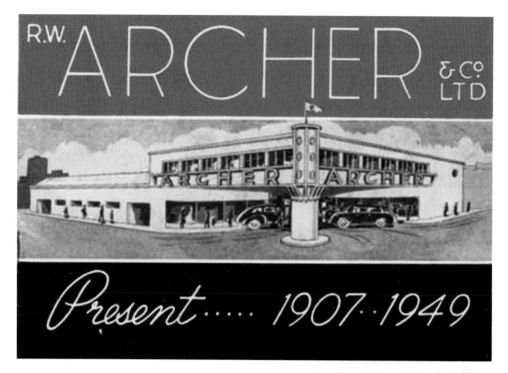

R.W. ARCHER & Cº LTD

Present.... 1907·1949

A booklet cover of Archer's Garage, Rathmines, 1949.
Courtesy of Ford Motors/Archer's/Richard Hamilton/
Heritage Ireland.

Working in Smith's Garage, Rathmines Road, 1950. The
person on right was a resident of Mount Pleasant Buildings,
Rathmines, which were demolished c.1972. Courtesy of Bob
Young/Memories of Rathmines/Dublin.ie/DCC.

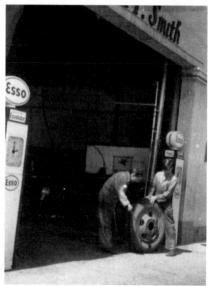

RESIDENTS DRIVEN 'ROUND THE BEND'

Some may also remember Archer's Garage, owned by R.W. Archer, a pioneer in the motor trade who had a special relationship with Henry Ford (I) and the Ford Motor Company in Cork. In 1907, the first Ford cars ever to be seen in Ireland went on display at the Irish Motor Show, held in the grounds of the Royal Dublin Society. The Ford exhibit consisted of three examples of the Model N. A Mr Archer signed the very first Irish sales contract for Ford at the show. However, because the Ford car was still widely unknown in Ireland, Archer initially found it difficult to make sales. But proof of the Ford's worth was forthcoming; the Model N won a gold

medal in the 1907 and 1908 Irish Reliability Trials. When the Model T was launched, the new car was an immediate success; sales doubled and redoubled. By 1913, some 600 Fords were sold throughout Ireland, and Rathmines residents played no insignificant part in the Ford success story.

THE PRINCESS AND THE CHIPPER

Rathmines is full of humour and characters of course, and the following story was overheard in Rody Boland's Pub in Upper Rathmines. A customer recalls:

> One night I overheard a group of Italian guys [tourists] trying to chat up two Irish girls and not getting very far. One of the tourists started waxing lyrical about one of the girls and her 'beautiful pale skin' and said, 'In my country, you would be a princess.' To which the Irish girl replied, 'And in my country, you'd work in a chipper, now get lost.'

No doubt the present generation are imbibing the ambience, the culture and the character of the area, just as previous generations did.

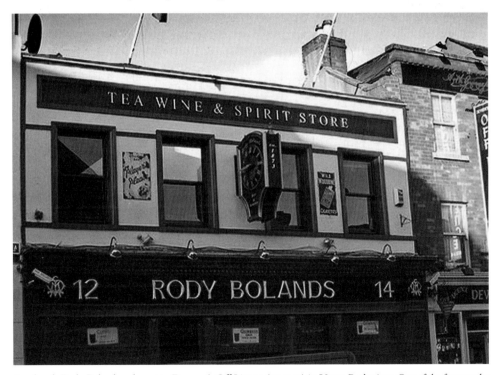

Landmark Rody Bolands pub next to Deveney's Off Licence (est. 1910) in Upper Rathmines. One of the few popular pubs in Rathmines along with Grace's, Slattery's, Rathmines Inn, Mother Reilly's, etc. Courtesy of Rathmines Heritage Society.

A view of the Grand Canal, Portobello Bridge and hospital (later hotel, nursing home and college of education) from Grove Road, Rathmines, c.1890. The main line of the Grand Canal runs from Ringsend in Dublin to the Shannon Harbour in County Offaly and is approximately eighty-two miles long with forty-three locks for barges and other transport. Work began on the Grand Canal in 1756 and in 1779 it opened for commercial traffic. In 1960 the last cargo boat passed along the Grand Canal. Courtesy of IHPC/OPW/The Grand Canal: A History.

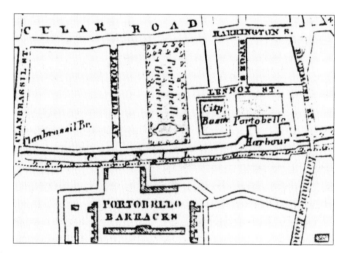

An early map of Rathmines and Portobello. It is part of an old hand-drawn map, dating from about 1840, author unknown, showing Portobello and environs. The name Portobello describes the stretch of the Grand Canal leading from Robert Emmet Bridge (Clanbrassil Street) to the bridge from South Richmond Street to Rathmines. Although usually referred to as Portobello Bridge, the correct name is La Touche Bridge. It is named after William Digges La Touche (1747-1803), scion of a prominent Dublin business family and a director of the Grand Canal Company. Like the Portobello area of London, Dublin's Portobello was ultimately named for the capture by Admiral Vernon in 1739 of Portobello, Colón on Panama's Caribbean Coast, during the conflict between the United Kingdom and Spain known as the War of Jenkins' Ear. Courtesy of NLI/DCL/HXHS/Rathmines Heritage Society.

1

Early Days and the Battle of Rathmines

Rathmines is a famous suburb on the south side of Dublin, about three kilometres south of the city centre. It effectively begins at the south side of the Grand Canal and stretches along the Rathmines Road as far as Rathgar to the south, Ranelagh to the east and Harold's Cross to the west.

Rathmines is an Anglicisation of the Irish *Ráth Maonais*, meaning 'ringfort of Maonas'. 'Raths' or ring forts, the remains of enclosed farmsteads, dated mainly from the early Christian period, where circular ramparts of earth, with a ditch, were erected to surround a house and outbuildings. Some also say the name 'Maonas' is perhaps derived from Maoghnes or the Norman name de Meones. The de Meones family came to Ireland from Hampshire in the late 1200s. Like many of the surrounding areas, Rathmines arose from a fortified structure that would have been the centre of civic and commercial activity from the Norman invasion of Ireland in the twelfth century. Rathgar, Baggotrath and Rathfarnham are further examples of Dublin place names deriving from a similar root.

Rathmines has a long history, stretching back centuries. Before the Norman invasion, Rathmines and the surrounding hinterland were part of the ecclesiastical lands called Cuallu or Cuallan, later the vast Parish of Cullenswood, which gave its name to a nearby area. Cuallu is mentioned in local surveys from 1326 as part of the manor of St Sepulchre (the estate, or rather liberty, of the Archbishop of Dublin, whose seat as a Canon of St Patrick's Cathedral takes its name from this). There is some evidence of an established settlement around a rath as far back as 1350. Rathmines was part of the Barony of Uppercross, one of the many baronies surrounding the old city of Dublin, bound as it was by walls, some of which are still visible.

Rathmines became a popular suburb of Dublin, attracting the wealthy and powerful seeking refuge from the poor living conditions of the city from the middle of the nineteenth century. A feature of Rathmines is the number of prominent individuals in Irish life who lived or were associated with the Rathmines area and who had an influence in one way or another on Irish history, politics, literature, science, art and society. These include Oliver Cromwell, Daniel O'Connell, Robert Emmet, and many more.

John Mitchel the Young Irelander, James Stephens the Fenian leader, Michael Collins, Cathal Brugha, the Yeats, Joyce and Osborne Families, Countess Markievicz, Lord Longford, Mamie Cadden, George Russell (Æ), the Gifford sisters, two former Taoisigh, Bram Stoker's wife and the 'Singing Priest' have all lived in the area at one time or another. It was, and still is, a much sought-after area, and it has also become the home for famous people in politics, the media, business, entertainment, music, the arts, literature and academia, amongst others. It has retained its distinctly cosmopolitan air.

THE COURSE OF IRISH HISTORY MIGHT WELL HAVE BEEN DIFFERENT

Arguably, Rathmines is best known historically for a bloody battle that took place there in 1649, during the Cromwellian conquest of Ireland, leading to the death of perhaps up to 5,000 people. The Battle of Rathmines took place on 2 August 1649 and led to the routing of Royalist forces in Ireland shortly after this time. Some have compared the Battle of Rathmines as equal in political importance to England's Battle of Naseby. It was significant because it enabled Cromwell's army to land in Dublin and continue the offensive against Ireland.

The Battle of Rathmines was fought in and around what is now the suburb of Rathmines, during the Irish Confederate Wars, the Irish theatre of the Wars of the

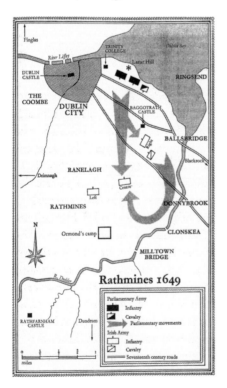

Map of the Battle of Rathmines. This was a pivotal battle in Irish history, as the defeat of the Irish Confederate forces enabled Oliver Cromwell to launch his invasion of Ireland through Dublin. Courtesy of Rathmines Heritage Society.

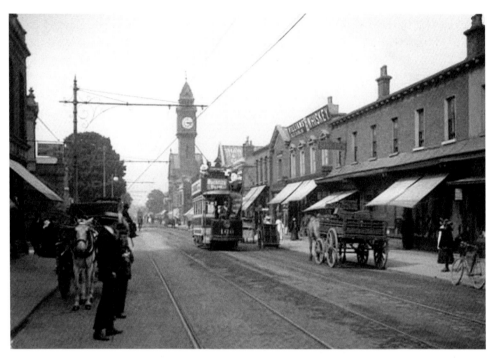

Rathmines c. 1922. The Battle of Rathmines took place on 2 August 1649. The battle lasted two hours, with 4,000 dead and 2,500 captured, according to some sources, and the lanes of Rathmines and Ranelagh were clogged with dead bodies. 'This is an astonishing mercy,' was Oliver Cromwell's comment on the unexpected victory for the Roundheads. Courtesy of NLI/DCL.

Three Kingdoms. It was fought between an English Parliamentarian army under Michael Jones, which held Dublin, and an army composed of Irish Confederate and English Royalist troops under the command of James Butler, 1st Duke of Ormonde. The battle ended in the rout of the Confederate/Royalist army and facilitated the landing in Ireland of Oliver Cromwell and his New Model Army several days later. In the next four years, the Cromwellian conquest of Ireland would be completed.

By 1649, Ireland had already been at war for eight years, since the outbreak of the Irish Rebellion of 1641. During this time, most of Ireland was ruled by the Irish Confederate Catholics, a government of Irish Catholics based in Kilkenny. The Confederates allied themselves with the English Royalists in the English Civil War, against the English Parliament, which was committed to re-conquering Ireland, suppressing the Catholic religion and destroying the Irish Catholic land-owning class. After much in-fighting, the Confederates signed a peace treaty with Charles I (who was soon to be executed by the Rump Parliament), agreeing to accept English Royalist troops into Ireland and put their own armies under the command of Royalist officers, in particular James Butler, 1st Duke of Ormonde. By 1649, the English Parliament held only two small enclaves in Ireland – at Dublin and Derry.

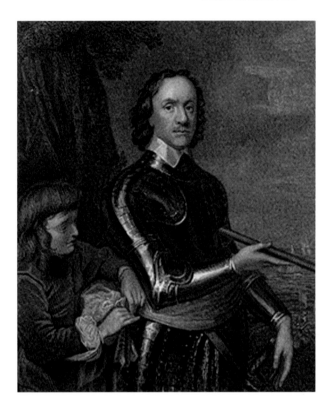

Contemporary picture of Oliver Cromwell, who nearly had his plans for the invasion of Ireland thwarted by the Battle of Rathmines (1649), which influenced the course of Irish history. Courtesy of HXHS/Rathmines Heritage Society.

In July 1649, Ormonde marched his coalition forces of 11,000 men to the outskirts of Dublin, to take the city from its Parliamentary garrison, which had landed there in 1647. Ormonde took Rathfarnham Castle and camped at Palmerston Park in Rathmines. The area from Ormonde's camp to the city of Dublin is now a heavily urbanised area, but in 1649, it was open countryside. Ormonde began inching his forces closer to Dublin by taking the villages around its perimeter, and to this end, sent a detachment of troops to occupy a ruined castle at Baggotsrath, on the site of present-day Baggot Street bridge.

However, Ormonde was not expecting Michael Jones, the Parliamentary commander, to take the initiative, and had not drawn up his troops for battle. Unfortunately for the Royalists, this is exactly what Jones did, launching a surprise attack on 2 August from the direction of Irishtown, with 5,000 men, and sending Ormonde's men at Baggotsrath reeling backwards towards their camp in confusion.

Too late, Ormonde and his commanders realised what was going on and they sent units into action piecemeal, to try to hold up the Parliamentarian advance so that they could form their army into battle formation. However, Jones's cavalry simply outflanked each force sent against them, sending them fleeing back south through the townland of Rathmines. The battle became a rout, as scores of fleeing Royalist and Confederate soldiers were cut down by the pursuing Roundheads. The fighting

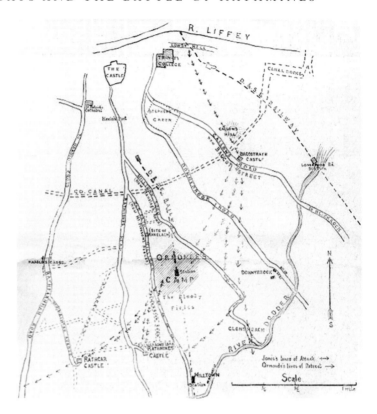

The field of the Battle of Rathmines, 2 August 1649. The modern features of the battlefield are indicated by the dotted lines. Courtesy of HXHS/Rathmines Heritage Group.

finally ended when the English Royalist troops under Murrough O'Brien, 1st Earl of Inchiquin, mounted a disciplined rearguard action, allowing the rest to get away. Ormonde claimed he had lost fewer than 1,000 men. Jones claimed to have killed around 4,000 Royalist or Confederate soldiers and taken 2,517 prisoner, while losing only a handful himself. Modern historians tend to believe Jones, because in contemporary warfare, if an army was put to flight and pursued, it very often took huge casualties, while the pursuers took very few. Ormonde also lost his entire artillery train and all his baggage and supplies.

In the aftermath of the battle, Ormonde withdrew his remaining troops from around Dublin, allowing Oliver Cromwell to land in the city (at Ringsend) with 15,000 veteran troops on 15 August. Cromwell called the battle 'an astonishing mercy', taking it as a sign that God had approved of his conquest of Ireland. Without Jones's victory at Rathmines, the New Model Army would have had no port at which to land in Ireland and the Cromwellian conquest of Ireland would have been much more difficult. Ormonde's incompetent leadership at Rathmines left many Irish Confederates disillusioned with their alliance with the English Royalists, and Ormonde was ousted as commander of the Irish forces in the following year.

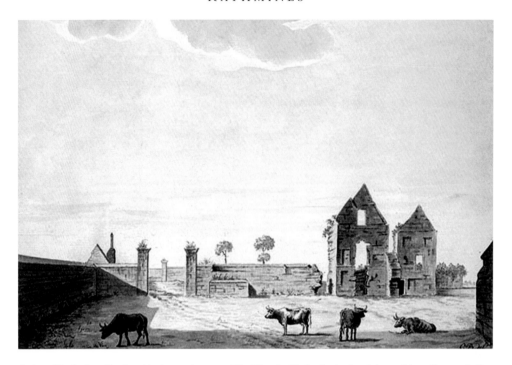

Ruins of Rathmines Castle, mid-nineteenth century. The Church of Ireland school and the teaching college are built on the grounds of where the castle once stood. The address would have been 96 Upper Rathmines Road, Dublin 6. It also had a Church of Ireland church in its grounds. There is a main road running in front of it and other quite big houses across the road. Rathmines Castle was built about 1820 by a Colonel Wynne. John Purser Griffith, Chief Engineer to the Dublin Port and Docks Board, later occupied it. Though 1820 seems to be the accepted date for this castle, another castle is shown on Taylor's map of 1816, where it is indicated as much closer to the eastern boundary of the grounds and is just marked as 'Castle'. There might have been a different castle on those grounds before. Wynne's castle is now demolished and in its place is the Church of Ireland Teachers' Training College and Kildare Place School, which moved here from Kildare Place in 1969. Courtesy of NLI/HXHS/Rathmines Heritage Society.

THE BLEEDING HORSE

The battle gave the names to several local landmarks. The Bleeding Horse pub (called the 'Falcon' at one time), which stands at the corner of modern Upper Camden Street, was established in 1649, when, after the Battle of Rathmines, a wounded horse wandered into a tavern. This made such an impression on the owner that he named his premises 'The Bleeding Horse'. There is a painting in this landmark pub that depicts the bleeding horse. It is one of Dublin's most historic pubs, and has been frequented over the years by literary greats such as Joyce, La Fanu, Gogarty and Dunleavy.

In addition, an area of Rathgar (now built over) was formerly known as the 'Bloody Fields', where it is believed that some of the fleeing Royalist soldiers were overtaken by the Parliamentarian cavalry, killed and subsequently buried.

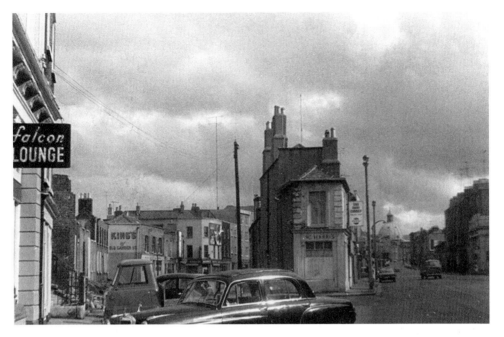

A view of Rathmines church dome from Camden Street, beside the Falcon Lounge (the Bleeding Horse pub) early 1960s. The area has a very dilapidated look to it. Courtesy of Dublin.ie.

Landmark Falcon Lounge (formerly and now, The Bleeding Horse) near Portobello Bridge in the 1960s. Courtesy of Dublin.ie.

THE EXPANSION OF RATHMINES: BUSINESSES OLD AND NEW

In the early 1790s, the Grand Canal was constructed on the northern edge of Rathmines, connecting Rathmines with Portobello via the La Touche Bridge (which through popular usage became better known as Portobello Bridge).

By 1823, Rathmines had nine grocers and an Italian warehouse owner, a vintner, a post office, two apothecaries, a victualler and poulterer, a haberdasher, a bootmaker, a dairy and a baker. Rathmines continued to grow, and in 1837 in Lewis's *Topographical Dictionary for Ireland*, it is described as being a considerable village and suburb with 1,600 inhabitants. Rathmines by now had its own police station and wool factory. Its houses were handsome, with some pretty, detached villas. The surroundings would still, of course, have been rural.

Dublin City was, at this time, becoming increasingly polluted and depressed, with tenements everywhere, and so the professional and middle classes and later the lower middle classes, began to leave the city and move to new housing developments in Rathmines and Pembroke.

Rathmines became a township in 1847. To encourage people to move to Rathmines and so stimulate house building, rates were kept as low as possible. As time went on, the demand grew for more suburban accommodation for the lower middle-class groups, and the commissioners were not slow to satisfy the demand. By the end of the nineteenth century, building had moved from fine, wide roads, like Palmerston and Leinster Roads, to smaller terraces. The borough of Rathmines had a unionist majority up to the late 1920s, when a local government reorganisation abolished all Dublin borough councils. In more recent times, Rathmines has diversified its housing stock and the wealthier beneficiaries of Ireland's economic boom of the 1990s and onwards have gentrified many houses.

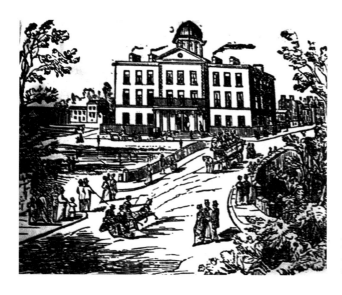

Left: *View of Portobello Bridge from Rathmines, mid-nineteenth century.* Courtesy of NLI.

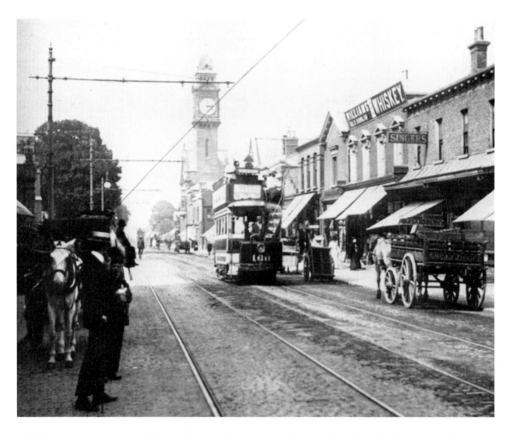

The Terenure tram passes through Rathmines on a fine day, c. 1912. The tram is outside what is now called the Swan Centre. Courtesy of NLI.

There are also a number of other landmark buildings and places of interest, including parks, shops and pubs, which hold strong memories for the residents, past and present.

THE RATHMINES SPA

For several hundred years, Rathmines was the location of a 'spa' – in fact a spring – the water of which was said to have health-giving properties. It attracted people with all manners of ailments to the area. In the nineteenth century it was called the 'Grattan Spa', as it was located on property once belonging to Henry Grattan, close to Portobello Bridge. The spa gradually fell into a state of neglect as the century progressed, until disputes arose between those who wished to preserve it and those (mainly developers) who wished to get rid of it altogether.

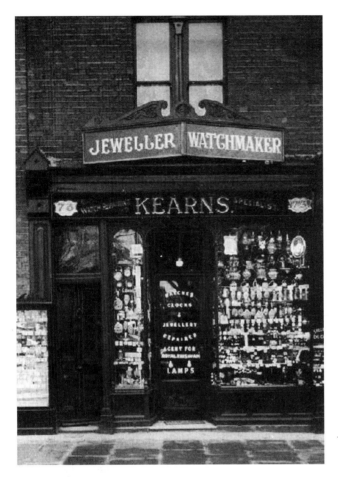

Shopfront from a bygone era.
Jeweller's shop on Rathmines Road,
1930s. Courtesy of NLI/DCL/
Rathmines Heritage Society.

In 1872, a Dr O'Leary, who held a high estimate of the water quality, reported that the spa was in 'a most disgraceful state of repair', upon which the property developer and alderman Frederick Stokes sent samples to the medical inspector, Dr Cameron, for analysis. Dr Cameron, a great lover of authority, reported, 'It was, in all probability, merely the drainings of some ancient disused sewer, not a chalybeate spring.' Access to the site was blocked up and the once popular spa faded from public memory.

Dartry Road in Rathmines was the scene of the still-controversial killing of IRA member Timothy Coughlin by police informer Sean Harling on the evening of 28 January 1928. It happened opposite Woodpark Lodge, where Harling lived at the time.

Rathmines is also home to two well-known primary and secondary schools, St Mary's College (C.S.Sp.) and St Louis Primary and Secondary School. Kildare Place National School, situated on the grounds of the Church of Ireland College of Education is a Church of Ireland sponsored primary school on Upper Rathmines Road.

2

Notable People and the Irish Revival

Frederick William Cumberland (1820-1881), architect, railway manager and politician, grew up in Rathmines. As did Andrew Cunningham, 1st Viscount Cunningham of Hyndhope and British Admiral of the Second World War. Paddy Finucane, Second World War fighter pilot, was born in Rathmines.

Richard Henry Geoghegan lived at 41 Upper Rathmines Road. He was the first Esperantist in the English-speaking world and was a friend of Irish Nationalist leader Joseph Mary Plunkett. He designed the original official Esperanto flag.

Irish patriot Robert Emmet. Robert Emmet (4 March 1778-20 September 1803) was an Irish nationalist, orator and rebel leader born in Dublin. He led an abortive rebellion against British rule in 1803 and was captured, tried and executed for high treason at Thomas Street, Dublin. Courtesy of HXHS.

ROBERT EMMET.
THE IRISH PATRIOT

PROPERTY AND BANKING

Frederick Stokes, property speculator and developer *par excellence*, lived at various times at 46 Rathmines Road, Kenilworth Square, Denmark Hill and Leinster Road West. He was a former Lord Mayor of Dublin, an alderman, and was responsible for the establishment of the Rathmines Township and for much of the development in the Rathmines and Portobello area.

William Digges La Touche (1747-1803), scion of a prominent Dublin business family (banking in particular; founder of one of Dublin's most historic banks, La Touche Bank) and a director of the Grand Canal Company, gave his name to Portobello Bridge (officially known as La Touche Bridge), over the Grand Canal linking Rathmines to the City Centre via Portobello. The bridge was built in 1791. The Digges La Touches were originally a Huguenot family.

'WITH O'LEARY IN THE GRAVE'

Fenian John O'Leary (b.23 July 1830; d.16 March 1907), lived at different times on Grosvenor Road (No. 30) and Leinster Road (No. 40). He identified with the views advocated by Thomas Davis and met James Stephens in 1846. He associated with Young

John Mitchel (1815-1875), one of the Young Irelanders, who lived at Ontario Terrace, overlooking the Grand Canal. He was an Irish Nationalist activist, solicitor and political journalist, who became a leading member of the Young Ireland movement and the Irish Confederation. He was elected to the British House of Commons, only to be disqualified because he was a convicted felon (due to striving for the social and political improvement of his fellow citizens in Ireland). His Jail Journal is one of Irish nationalism's most famous texts. Courtesy of HXHS.

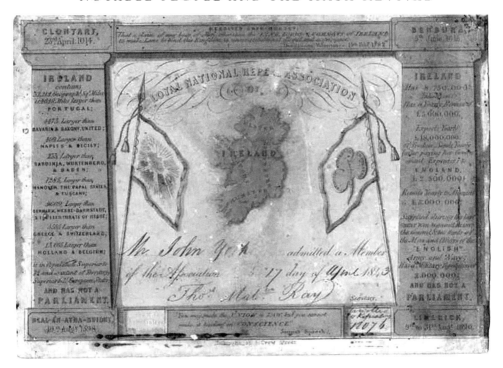

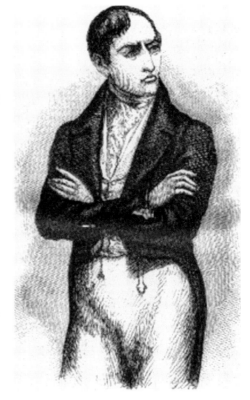

Membership card of Dublin-born political activist and administrator Thomas Mathew Ray to the Loyal National Repeal Association of Ireland (1843). Signatory Ray (1801-81) was on a charge of indictment for conspiracy in the case of the Queen along with Daniel O'Connell and Charles Gavan Duffy in the spring of 1843. The Loyal National Repeal Association was formed from the Repeal Association founded in 1840. The aim of the association was to repeal the union between Britain and Ireland and establish an Irish Parliament. Ray was secretary of the National Trades Political Union (1832), secretary of the Precursor Society (1838), and secretary of the Repeal Association, until its dissolution in 1848. He died 5 January 1881 at 5 Leinster Road, Rathmines, and was buried in Glasnevin Cemetery. Courtesy of Whyte's/Adam's/Rathmines Heritage Society.

Robert Emmet, Irish patriot. The bridge over the Grand Canal at the junction of Harold's Cross Road and Grove Road, Rathmines, is called Emmet Bridge, because of his association with the area. There was a secret underground passage linking his lodgings on Harold's Cross Road to the Grand Canal, from where he was able to escape any pursuers. Courtesy of HXHS.

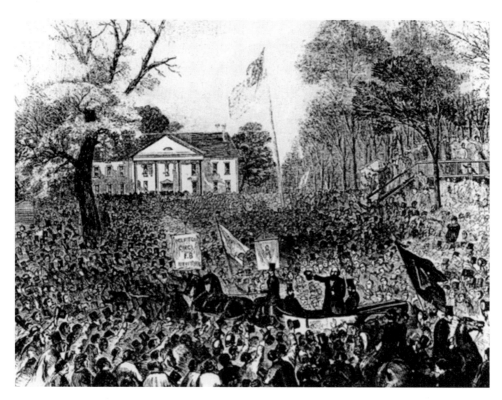

James Stephens (a.k.a. Stevens), 1825-1901. Resident of 2 Leinster Square. Was born and educated in Kilkenny. He began working as a civil engineer with the Limerick and Waterford Railway in 1843. Stephens joined the Young Irelanders in 1847 and quickly rose to prominence in the movement. He was wounded during the 1848 Rising at Ballingarry, County Tipperary, but managed to escape to France where he was one of a circle of Irish exiles including Thomas Clarke Luby and John O'Mahony who founded the Irish Republican Brotherhood. Stephens returned to Ireland as Head Centre of the IRB in 1856, in which capacity he organised Fenian cells throughout Ireland and was responsible for affiliating the Phoenix Association with the Fenian movement. In 1858, Stephens travelled to America to raise funds for the IRB, and when he returned to Ireland in 1859 the authorities knew his identity and he was forced to return to America. Stephens returned to Ireland in 1861 and continued to fight for independence. Courtesy of NLI/HXHS/Rathmines Heritage Society.

Irish patriot James Stephens (a.k.a. Stevens) greeting a crowd in the United States in 1858. James Stephens, railway engineer, republican nationalist, and founder of the Fenians, lived at 2 Leinster Square, Rathmines. Courtesy of HXHS/Rathmines Heritage Society.

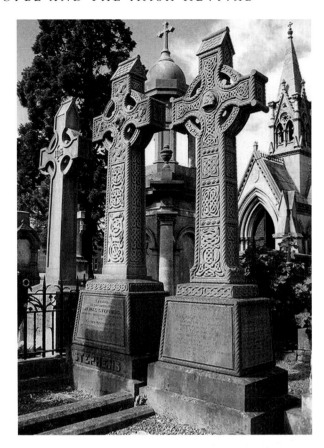

Fenians James Stephens (of Leinster Square) and John O'Leary (of Leinster Road and Grosvenor Road) buried side by side in Glasnevin Cemetery. A panel on the Celtic cross (O'Leary) reads, 'A day, an hour of virtuous liberty is worth a whole eternity in bondage.' Courtesy of Glasnevin Cemetery.

Irelanders Charles Gavan Duffy, James Fintan Lalor, Thomas Francis Meagher and John Mitchel. After the failure of the 1848 Tipperary Revolt, O'Leary attempted to rescue the leaders from Clonmel Gaol, and was himself imprisoned from 5 September 1849. A further uprising in Munster on 16 September 1849 gave him an opportunity to escape from prison, which he took. On 14 September 1865, O'Leary was arrested, and tried on charges of high treason. He was sentenced to twenty years' penal servitude, of which nine years were spent in English prisons prior to his exile to Paris in 1874. Following the Amnesty, he returned to Ireland in 1885 with his sister, the poet Ellen O'Leary, both of whom became important figures within the Dublin cultural and nationalist circle which included W.B. Yeats, Maud Gonne, Rose Kavanagh, Rosa Mulholland, Dora Sigerson and Katharine Tynan. He is buried next to Fenian James Stephens in Glasnevin Cemetery. In his poem 'September 1913', W.B. Yeats laments the death of O'Leary with the line, 'Romantic Ireland's dead and gone; it's with O'Leary in the grave'.

Cathal Brugha, Irish nationalist leader, lived on Rathmines Road, as did General Richard Mulcahy and his family. Nora Connolly O'Brien, second daughter of James Connolly, lived on Belgrave Square, Rathmines. She was an activist and writer, and also a member of the Irish Senate.

UNLIKELY REBELS

Grace Gifford is one of the tragic stories of the 1916 Easter Rising. Grace, one of the famous Gifford sisters, was an Irish artist and cartoonist who was active in the Republican movement. She was born in Rathmines and married Joseph Mary Plunkett, one of the leaders of the 1916 Rising, only a few hours before he was executed. It was her interest in Catholicism which led Grace to Joe Plunkett, who was intensely devoted to his religion, as well as to the Republican cause. His sacrificial romanticism was expressed in poems like 'I see His Blood upon the Rose'. The wedding was reported all over the world. Grace, like Sarah Curran before her, who had loved Robert Emmet, had become a tragic symbol of Ireland's struggle with England.

The Gifford sisters were originally Protestant and unionist but later embraced Catholicism and nationalism. Grace and her sisters were raised in their mother's Protestant faith and the sons were raised as Catholics. Her parents followed a custom known as the 'Palatine Pact', which meant that the boys of this mixed marriage were reared as Catholics, the girls as Protestants.

The sisters were heavily involved with the leaders of the 1916 Rising, such as Constance Markievicz, Thomas MacDonagh (who married Grace's sister Muriel), Patrick Pearse and Maud Gonne. They became strong supporters of the Irish Women's Franchise League, a militant organisation working to obtain voting rights for women.

The six sisters were Grace (later Plunkett), Muriel (later MacDonagh, having married Thomas MacDonagh in 1912), Nellie (later Donnelly), Sydney (later Czira), Kate and

Marriage certificate of the leader Joseph Mary Plunkett and Grace Gifford. Grace Gifford's brief marriage to the executed rebel leader Joseph Mary Plunkett has tended to overshadow her family's deep commitment to the cause of the Irish Republic. They lived in Rathmines. Courtesy of Whyte's/Adam's/HXHS/Rathmines Heritage Society.

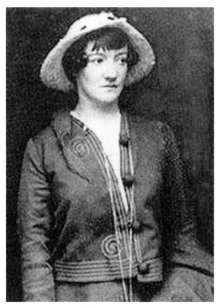

Grace Evelyn Gifford Plunkett (4 March 1888-13 December 1955). Courtesy of Rathmines Heritage Society.

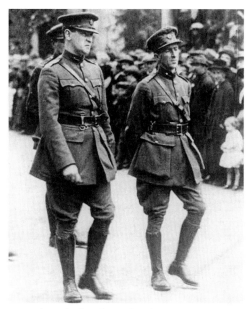

Generals Michael Collins and Richard Mulcahy, based in Cathal Brugha Barracks, Rathmines, at the funeral of Arthur Griffith in 1922. Courtesy of NLI.

Ada. The first two married signatories of the Easter Rising proclamation and were thus to be widowed. Nellie was active during the Rising and was in charge of feeding the Volunteers in the Royal College of Surgeons garrison. Grace's younger sister Sydney became a writer, describing the Rathmines of their childhood as a stifling and snobbish place where anyone who had an original thought was written off as eccentric. The sisters were six of the twelve children of Frederick Gifford and his wife, Isabella Burton. They lived in a large house on Palmerston Road, Rathmines.

Grace's last years were marred by poor health. On 13 December 1955, a neighbour noticed that she had not collected her single bottle of milk or her post from outside her flat in South Richmond Street, Portobello. Grace Gifford Plunkett had died alone, in bed. She was buried with full military honours at Glasnevin, near, but not in the Republican plot.

GHOSTS, SCRIBES AND REVOLUTIONARIES

Lafcadio Hearn, the ghost-story writer who settled in Japan, was brought up in Leinster Square and Prince Arthur Terrace, Rathmines. Patrick Lafcadio Hearn (b. 27 June 1850; d. 26 September 1904), also known as Koizumi Yakumo, was an international writer, best known for his books about Japan, especially his collections of Japanese legends and ghost stories.

Hearn was born in Lefkada (the origin of his middle name), one of the Greek Ionian Islands. He was the son of Sergeant Major Charles Bush Hearn (of County

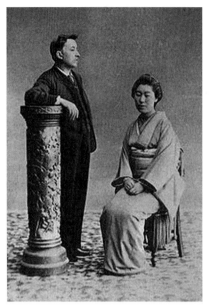

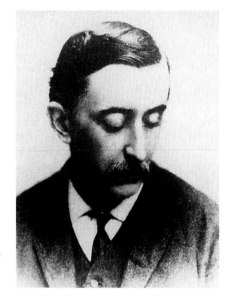

Former Leinster Square resident Lafacido Hearn and his Japanese wife. Patrick Lafcadio Hearn (27 June 1850-26 September 1904) was also known as Koizumi Yakumo, after gaining Japanese citizenship. He was reared in Rathmines from the age of two. He was an author, best known for his books about Japan, and he is especially well known for his collections of Japanese legends and ghost stories. Note the way he is facing – he always preferred to be photographed this way so that his left eye could not be seen. HXHS. Courtesy of Rathmines Heritage Society.

Patrick Lafacido Hearn of Leinster Square became an expert on Japanese Haiku poetry. He is commemorated by two plaques in Leinster Square and Prince Arthur Terrace, and another in Leeson Street. Courtesy of Rathmines Heritage Society.

Offaly) and Rosa Antoniou Kassimati, a Greek woman of noble Cerigote lineage. His father was stationed in Lefkada during the British occupation of the islands. Hearn moved to Dublin, Ireland, at the age of two, where he was brought up in Rathmines.

In 1890, after having worked in the USA, Hearn went to Japan with a commission as a newspaper correspondent, which was quickly broken off. It was in Japan, however, that he found his home and his greatest inspiration. Hearn became known to the world through the depth, originality, sincerity, and charm of his writings about the country. In later years, some critics would accuse Hearn of exoticising Japan, but as the man who offered the West some of its first glimpses into pre-industrial Japan, his work still offers valuable insight today.

HAPPY AND SAD FACES

The Earl of Longford had a large house in the Grosvenor Park area of the Leinster Road, between Rathmines Road and Harold's Cross. Pakenham is best remembered

Etching of a young William Carleton, novelist. His Traits and Stories of the Irish Peasantry *(1830-3) won him a great reputation. He continued to write until his death in Rathmines on 30 January 1869. His works are important sources for life and attitudes in nineteenth-century Ireland.* Courtesy of Rathmines Writers' Workshop.

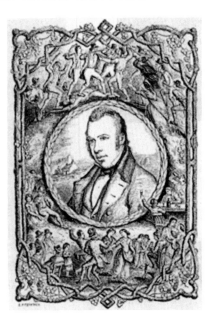

for his involvement in the founding of the Gate Theatre with Michael MacLiamoir and Hilton Edwards. He was a playwright and poet, and also sat as a member of the Republic of Ireland Seanad (Senate) between 1946 and 1948. He lived on Leinster Road until his death in 1961.

He is buried in Mount Jerome Cemetery. His headstone describes him as a poet and patriot. 'Happy and Sad Masks', the symbol of the theatre, are inscribed on the sides of his headstone. His house was demolished in the 1970s and replaced with townhouses, bearing the same name, Grosvenor Park. He was also related to the founder of St Paul's Retreat, Mount Argus, Fr Paul Mary Pakenham.

ME JEWEL AND DARLIN' RATHMINES

Éamonn MacThomáis was born in Rathmines in 1927. He was an author, broadcaster, historian, republican, advocate of the Irish language and a lecturer. He is noted for numerous RTÉ documentaries on his native Dublin.

Dr Kathleen Lynn, an outstanding and pioneering doctor and an activist in the fight for Irish independence, had her clinic and lived in Rathmines. Lynn House, the headquarters of the Irish Medical Council, on Rathmines Road near Portobello Bridge, is named after her.

Young Irelander John Mitchel was living with his family at 8 Ontario Terrace when he was arrested in 1848. Another Young Irelander, Charles Gavan Duffy also lived in Rathmines.

Conor Cruise O'Brien was born in 1917 in Rathmines, the only child of Francis Cruise O'Brien, a journalist who worked for the *Freeman's Journal*, and Kathleen Sheehy.

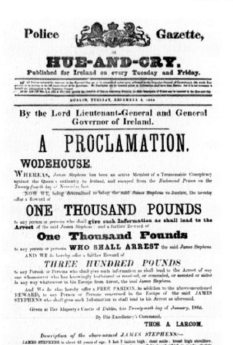

The Police Gazette, *or* Hue-and-Cry,
*Dublin, Tuesday 6 December 1866, with the
Governor-General's proclamation offering a reward of
£1,000 for the arrest of James Stephens (of Leinster
Square, Rathmines), following his escape from
Richmond Prison in Dublin.* Courtesy of NLI/
Rathmines Heritage Society.

*Sir Charles Gavan Duffy, 1816-1903, Irish-
Australian statesman. Born in Ireland and lived in
Rathmines (at Homeville, just off the Rathmines Road,
and Leinster Square). He founded* The Nation *(1842),
a patriotic Irish literary journal.* Courtesy of HXHS/
Rathmines Heritage Society.

*Picture of Sir Charles Gavan Duffy (1816-1903),
by unknown engraver (1877). Duffy was a Young
Irelander, Irish nationalist founder of* The Nation
*newspaper, and Australian statesman. Lived at
Holmeville and Leinster Square, Rathmines.*
Courtesy of La Trobe Picture Collection, State
Library of Victoria/Rathmines Heritage Society.

Rathmines resident Charles Gavan Duffy with John Blake Dillon and Thomas Davis, founders of the Irish patriotic newspaper The Nation, *which had a huge influence on Irish nationalist politics. All three were members of Daniel O'Connell's Repeal Association, and would later come to be known as Young Irelanders.* Courtesy of HXHS/Rathmines Heritage Society.

Walter Osborne, a famous Irish impressionist painter, was born at 5 Castlewood Avenue.

George William Russell (Æ) was educated at Rathmines School and lived at 65 Grosvenor Square. Likewise, the famous Hollywood film director Rex Ingram (in No.58). Francis Sheehy-Skeffington, Irish suffragist, pacifist and writer, lived in 11 Grosvenor Place, Rathmines. Annie M.P. Smithson, novelist, nurse and nationalist, lived at 12 Richmond Hill until her death.

THE MOON AND THE STARS

The Joyce family grew up on Castlewood Road, Rathmines. James Joyce mentions Portobello Barracks (now Cathal Brugha Barracks) in Chapter 2 of *Ulysses*. Thomas and Anna Haslam, leaders of the Irish suffragette movement, lived on Leinster Road. Nurse Mamie Cadden, who was sentenced to death for murder, ran a nursing home on Rathmines Road. Sean O'Casey, in his famous play *The Plough and the Stars*, has a character known as 'The Woman from Rathmines'. He also mentions Rathmines church.

Thomas Grubb (1800-1878), maker of scientific instruments, was born in Waterford in 1800. In the 1830s he set up an engineering works in Dublin at Charlemont Bridge

near the Grand Canal and built for himself a small observatory. The Revd T.R. Robinson suggested that Grubb should mount the 13.5-inch lens owned by E.J. Cooper of Markree and he ordered a 15-inch reflector for Armagh Observatory. Grubb invented a novel lever support system for the primary mirror of the Armagh reflector; this was later adopted in Lord Rosse's Leviathan. Grubb constructed precision instruments for Trinity College and twenty sets of magnetometers for a global network of magnetic observatories. About 1840, Thomas Grubb became 'Engineer to the Bank of Ireland' where he was responsible for designing and constructing machinery for engraving, printing and numbering banknotes. When Grubb received an order to build a 48-inch reflector for Melbourne Observatory, he and his son Howard set up a new works in Rathmines, at Observatory Lane. The firm prospered and built some of the world's greatest telescopes,

Thomas Grubb (1800-1878), born probably near Portlaw, County Waterford, was an optician and founder of the Grubb Telescope Company. He started out in 1830 in Dublin as a metal-billiard-table manufacturer. He diversified into making telescopes and erected a public observatory near his factory at Observatory Lane, Rathmines. As makers of some of the largest and best-known telescopes of the Victorian era, the company was at the forefront of optical and mechanical engineering. Courtesy of the National Science & Engineering Plaques Committee.

many of which are still in operation, including the famous Birr Castle telescope.

Grubb was elected a Member of the Royal Irish Academy in 1839 and a Fellow of the Royal Society in 1864.

THE REBEL COUNTESS

Countess Constance Markiewicz, Irish revolutionary, lived in Rathmines for many years. Constance was born into a wealthy Anglo-Irish family, the Gore-Booths, in County Sligo in 1868. As she grew up, the family divided their time between their country estate in Sligo and their townhouses in London and Dublin. After a visit to the Ukraine, she and her new husband Kazimierz Dunin-Markiewicz returned to live in a house provided by the Constance's mother in Rathmines (49b Leinster Road and

called Surrey House) to bring up her daughter Maeve and stepson Stanislaus. She set up and managed a soup kitchen to support the families of workers during a general strike in 1913 – called 'the Dublin Lockout' – which was led by Jim Larkin. She was particularly active in the 1916 Rising and the War of Independence. Her house in Rathmines was a hive of activity, with the 1916 leader James Connolly amongst the many frequent visitors. The house was raided after the Rising.

Having fought in the 1916 Rising, she was arrested and sentenced to death. As a woman, her sentence was commuted to life imprisonment, unlike the other leaders who were executed. The only other rebel leader who escaped execution was Éamon de Valera, who held US and Spanish citizenship on account of his father.

In 1917, she and all the remaining 1916 prisoners were released. In 1918, she was elected to the British House of Commons. She was the first woman to be elected to Parliament. As a nationalist, she refused to take her seat. Instead, the hugely successful Sinn Féin, having ousted the Irish Parliamentary Party, set up their own parliament in Dublin, called 'Dáil Éireann'. Constance was appointed Minister for Labour and was one of the first women in the world to hold a cabinet position.

Wiliam Butler Yeats wrote a poem entitled 'In Memory of Eva Gore-Booth and Con Markievicz', in which he described the sisters as 'two girls in silk kimonos, both beautiful, one a gazelle'.

The Cuala Group included various professionals, businessmen and others in the Rathmines area of Dublin, as well as relatives of the 1916 leaders, such as Frances Ceannt and Joseph MacDonagh. Interesting content concerning the Rathmines Urban District Council: 'the convalescent home and the asylum of Freemasonry and Orangeism'. Also 'Statement by Rt Revd Michael J. Gallagher DD dealing with matters which arose out of the visit to the United States of America of the Hon. Éamon de Valera' (1920), p. 10. Dr Gallagher was National President, Friends of Irish Freedom. Courtesy of Whyte's/Rathmines Heritage Society.

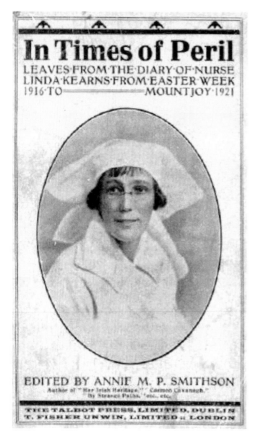

In Times of Peril

LEAVES·FROM·THE·DIARY·OF·NURSE
LINDA·KEARNS·FROM·EASTER·WEEK
1916·TO————————MOUNTJOY·1921

EDITED BY ANNIE M. P. SMITHSON
Author of "Her Irish Heritage," "Carmen Cavanagh,"
"By Strange Paths," &c., etc.

THE TALBOT PRESS, LIMITED, DUBLIN
T. FISHER UNWIN, LIMITED : LONDON

Charting the War of Independence through one of its heroines, In Times of Peril: Leaves from the Diary of Nurse Linda Kearns from Easter Week, 1916 to Mountjoy (1921) was edited by Annie M.P. Smithson, for many years a best-selling Irish author. Dedicated to Éamon de Valera. First edition, with portrait of the author. Smithson lived at 12 Richmond Hill until her death. A few doors away lived another writer, Dora Sigerson Shorter. Courtesy of NLI/ HXHS/Rathmines Heritage Society/Rathmines Reading Workshop.

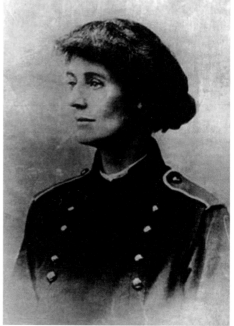

The 'Rebel' Countess, Constance Markievicz, Irish patriot and nationalist, who lived on Leinster Road. Courtesy of NLI/Rathmines Heritage Society.

She joined Fianna Fáil on its foundation in 1926, chairing the inaugural meeting of the new party in La Scala Theatre. In the June 1927 general election, she was re-elected to the fifth Dáil as a candidate for the new Fianna Fáil party, which was pledged to return to Dáil Éireann, but died only five weeks later, before she could take up her seat.

She died at the age of fifty-nine, on 15 July 1927, possibly of tuberculosis (contracted when she worked in the poorhouses of Dublin) or complications related to appendicitis. Her estranged husband and daughter and beloved stepson were by her side. She was buried in Glasnevin Cemetery, Dublin. Éamon de Valera, the Fianna Fáil leader, gave the funeral oration.

LEADERS AND CHANGE IN IRELAND

Francis Sheehy-Skeffington, Irish suffragist, pacifist and writer, lived in 11 Grosvenor Place, Rathmines. During Easter Week 1916, Francis Sheehy-Skeffington was detained and shot dead without charge or trial at Portobello Barracks (later Cathal Brugha Barracks) by Captain Bowen-Colthurst of the Royal Irish Rifles. The British Army court-martialled Colthurst on charges of murder, finding him guilty but insane.

General Richard Mulcahy (Lissenfield, Rathmines Road) was an Irish politician, army general, Commander-in-Chief, leader of Fine Gael and Cabinet Minister. He fought in the 1916 Easter Rising, served as Chief of Staff of the Irish Republican Army during the War of Independence and was commander of the pro-Treaty forces in the Irish Civil War. He and Michael Collins were largely responsible for directing the military campaign against the British during the War of Independence. His son, named Risteárd Mulcahy, was for many years a cardiologist in Dublin. The family lived in

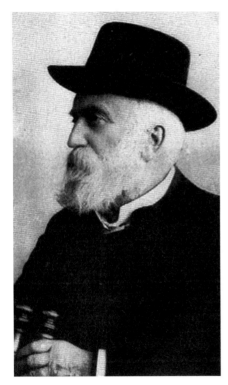

Grace Gifford in her wedding dress. The Gifford sisters of Rathmines, Grace (later Plunkett), Muriel (later MacDonagh), Nellie (later Donnelly), and Sydney (later Czira) were key figures in the Republican struggle during the 1916 period. Courtesy of HXHS/DC/Rathmines Heritage Society.

Charles Benson, founder and headmaster of the Rathmines School. The register of Benson's school reads like a potted social history of the Church of Ireland middle class in late Victorian Rathmines and Rathgar. His former pupils erected a memorial to Benson in the south aisle in St Patrick's Cathedral, Dublin. It describes Rathmines as 'one of the largest and most successful private schools in Ireland during the XIXth century'. And, in a tribute to Benson, it says, 'Few teachers have been more stimulating and inspiring than this servant of God, who taught and acted on his motto, Ora et Labora.' Courtesy of Canon Patrick Comerford, Christchurch Cathedral.

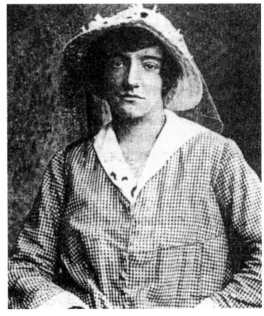

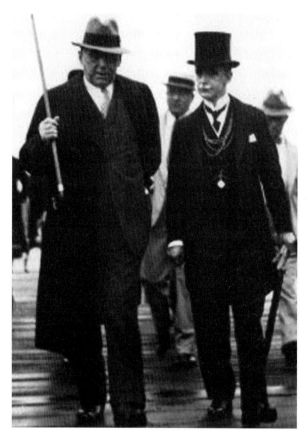

Dublin's famous Lord Mayor Alfie Byrne, seen here on the right (with mayoral chains and bowler hat) in the 1930s. Alfred Byrne (17 March 1882-13 March 1956), also known as Alfie Byrne, was an Irish nationalist politician, who served as both an MP in the House of Commons of the United Kingdom of Great Britain and Ireland, and as a TD in Dáil Éireann. As Lord Mayor of Dublin, he was known as the 'shaking hand of Dublin'. Byrne was elected the Lord Mayor an unprecedented nine times without a break from 1930 until 1939. He also served as the Lord Mayor in 1954 and 1955. He lived at 46 Palmerston Road, Rathmines. Courtesy of NLI/ HXHS/Rathmines Heritage Society.

Rathmines from 1922 to 1966 and the house was directly opposite Rathmines Catholic church. It has since been demolished and apartments and houses built on the site.

The actor and Gaelgóir Brendán O'Dúill (Grosvenor Square); Florence Stoker, wife of Bram Stoker, author of *Dracula*; Revd Dr Charles Benson, founder of the Rathmines School, and the Fenian John O'Leary, also lived in the area.

TOMBS AND TOMES

The tomb of former Rathmines resident (Richmond Hill) and noted writer Dora Sigerson Shorter (1866-1918) is in Glasnevin Cemetery. A secret was discovered during the process of dismantling the monument for renovation purposes. Workers made a very interesting discovery when they removed the canopy that stands over the statue. A long, lead cylinder was built into the masonry. The sealed cylinder is a time capsule entombed with Dora Sigerson at the time of her interment.

It is purported to contain important documents and ephemera germane to the history of her day. The cylinder was handed over to the Irish government. The contents

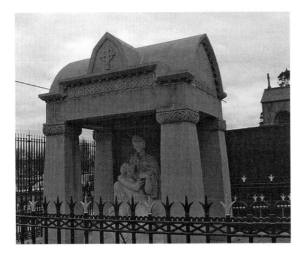

Tomb of Dora Sigerson Shorter in Glasenevin Cemetery. Dora Sigerson was also a gifted sculptor. She designed the memorial to the rebel dead which stands at the center of her own monument and bequeathed funds in her will for its erection. The white Carrera marble statue is evocative of the Pieta, *the depiction of Christ lying dead across Mary's lap, which stands in the Basilica in Rome. The female figure in Sigerson's statue is Mother Ireland and lying across her lap is one of Ireland's lost warriors. The uniform of the warrior figure is clearly that of a 1916 rebel, and his face bears a striking resemblance to that of Patrick Pearse, executed leader of the Easter Rising.* Courtesy of Glasnevin Cemetery.

Mount Jerome Cemetery, where former Rathmines residents now rest in peace. Among those interred there include Thomas Davis, the Guinness family, the Wilde family, the Osborne family, George Russell (Æ), William Carleton, and Jack B. Yeats. Courtesy of Mount Jerome.

of the time capsule have not been revealed, but may be released at 'a more appropriate time' (perhaps 2016, the 100th anniversary of the Rising) or it may be reinterred and left for future generations to discover and open.

Sigerson was a major figure of the Irish Literary Revival, publishing many collections of poetry, from 1893. Her friends included Katharine Tynan, a noted Irish-born poet and author, and Alice Furlong, writer and poet. Katherine Tynan wrote in a biographical sketch that Sigerson 'died of a broken heart' after the 1916 executions.

TEA AND GUNS

Darrell Figgis was born Rathmines and raised in India. He worked as tea broker in London and Calcutta (1898-1910) and published poems in *A Vision of Life* (1909), with a preface by G.K. Chesterton, securing him a position as a reader for Dent (1910-13), and eventually a job as editor. He wrote fiction, including *Broken Arcs* (1911), and then returned to Ireland in 1913, when he bought a cottage on Achill Island. He edited a volume of stories of William Carleton (Rathmines resident) and wrote the play *Queen Tara*, which was produced by F.R. Benson at the abbey in 1913.

A SECOND
CHRONICLE OF JAILS

DARRELL FIGGIS

Irish patriot Darrell Figgis on the front cover of his book, A Chronicle of Jails *(1917), with* A Second Chronicle of Jails, The Historic Case for Irish Independence. *A rare book. Courtesy of Rathmines Writers' Workshop.*

He was involved with Bulmer Hobson in the famous Howth gunrunning, following a meeting of 8 May 1914 at the home of A.S. Green in which he was instructed to buy arms in Germany for the Irish Volunteers. ('Let us buy arms and so at least get into the problem.') He was imprisoned in 1917 and 1919. He was Honorary Secretary of Sinn Féin from 1917 to 1919. Meanwhile, he continued his writing with novels *Jacob Elthorne* (1914) and *Children of Earth* (1918), about life on Aran. He became a TD for Dáil Éireann in 1918, following the landslide Sinn Féin victory.

PIP PIP AND ALL THAT IN RATHMINES

Fine buildings, villas and houses, built many years ago, still grace the elegant roads of Rathmines. These roads, Belgrave Road/Square, Bessborough Parade, Palmerston Road, Temple Road, Grosvenor Road/Square, Windsor Road, Cowper Road, Prince Arthur Terrace, are all redolent of a different era, when Rathmines was a bastion of southern unionism.

At the same time, however, some of Ireland's most notable patriots, Repeal activists, Young Irelanders, Fenians, and those involved in the fight for Irish freedom, also lived in the area. In fact, some of the major themes of Irish history, from the Normans to Cromwell, Henry Grattan, Robert Emmet, Daniel O'Connell and Catholic Emancipation, the Young Ireland movement, the Fenians, the Celtic Revival and on to 1916 and the subsequent War of Independence and Civil War, were played out in Rathmines and may be seen in this short introduction to the places and people of this unique suburb.

3

Cathal Brugha Barracks and General Michael Collins

The building of Cathal Brugha Barracks, or Portobello Barracks as it was originally known, began in 1810 and was completed in 1815. It was built on land owned by the Earl of Meath. Portobello, which means 'Beautiful Harbour' in Spanish, was so named by Columbus. It became the main Spanish port on the Caribbean Sea coast of Panama for the export of gold and silver from the new world to Spain. Sir Francis Drake looted and burned the city in 1570 and was buried at sea in its harbour. To commemorate this event, many places in England and in Ireland were named Portobello. Mount Pleasant Avenue in Rathmines was named 'Porto Bello' in 1696, and when the Grand Canal was built at the beginning of the nineteenth century, the canal bridge to Rathmines was called Portobello Bridge. The area therefore became known as Portobello and so the barracks, adjoining the canal, became known as Portobello Barracks.

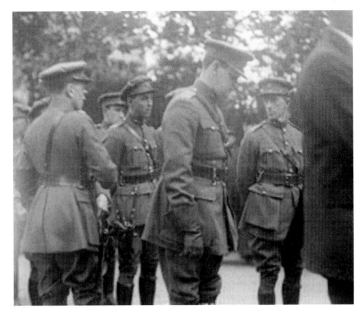

General Michael Collins in Portobello Barracks, 1922. Portobello Barracks was a very busy place at that time, as it became the National Army's Headquarters with General Michael Collins as Commander-in-Chief, General Mulcahy as his Deputy and Minister for Defence, Major General Sean McMahon as Quartermaster General, and Major General Gearoid O'Sullivan as Adjutant General. Courtesy of NLI.

The first troops to occupy the barracks were the 6th Dragoon Guards under the command of Major General A.J. Goldie. The garrison church was added in 1842 and the canteen block in 1868. In 1887, the additional land was purchased, making the total area of the barracks thirty-six acres. The barracks was designed as a cavalry barracks and remained so until the cavalry left for McKee Barracks in 1888. Units who served in the barracks included the Royal Scots Fusiliers, the Royal Munster Fusiliers, the Sherwood Foresters, the Derby Regiment, the Durham Light Infantry, the Warwickshire Regiment, the Middlesex Regiment, the East Lancs Regiment, the Buffs Regiment, the Wiltshire Regiment, the Royal Inniskilling Fusiliers, and the Royal Irish Rifles. As you can imagine there were many incidents at the barracks, and here are some interesting facts:

In 1817, William Windham Saddler made a successful flight in a hot air balloon from the barracks to Holyhead in Wales. On 22 June he ascended from Portobello Barracks. He rose to a great height, obtained the proper westerly current, and managed to keep the balloon in it across the St George's Channel. In mid-channel he wrote, 'I enjoyed at a glance the opposite shores of Ireland and Wales, and the entire circumference of Man.' Having started at 1.20 p.m., he alighted a mile south of Holyhead at 6.45 p.m.

During the 1916 Rising, the barracks was actively involved in quelling the insurgents. They set up an observation post at the top of the Rathmines Town Hall tower. On St Patrick's Day 1916, the Countess of Limerick distributed shamrock to the troops. A few weeks later, during the Easter Rising, troops from the barracks killed a number of civilians in the Rathmines area, and three prisoners, Mr Dickison, Mr McIntyre and Mr Sheehy-Skeffington, the editor of *The Irish Citizen*, were shot 'without trial' in the barrack guardroom. Captain Bowen-Colthurst, a Company Commander in the Royal Irish Rifles who ordered the shootings, was later adjudged to be insane at the subsequent inquiry and court-martial. He spent eighteen months in Broadmoor Prison.

Troops from the barracks were involved in other actions throughout the city. One such

Michael Collins in uniform at Portobello Barracks, Dublin, 1922. Courtesy of the NLI/ Cathal Brugha Barracks.

action took place when a Major Vance led troops from Portobello Barracks against the South Dublin Union, where Cathal Brugha was the second in command of the defending forces. During the Troubles (1917-1921), Portobello was occupied by 5th Battalion, Worcestershire Regiment, and 2nd and 3rd Battalions of Royal Berkshire Regiment. On 17 May 1922, Commandant General Ennis, O/C Second Eastern Division, led Irish troops into the barracks to take over possession from Major Clarke, 5th Battalion, Worcestershire Regiment. The first O/C of the barracks under Irish rule was Captain McManus.

Portobello Barracks was a very busy place at that time, as it became the National Army's Headquarters, with General Michael Collins as Commander-in-Chief, General Mulcahy as his deputy and Minister for Defence, Major General Sean McMahon as Quartermaster General and Major General Gearoid O'Sullivan as Adjutant General. In addition, it accommodated four infantry battalions. On 12 August 1922, General Collins left Portobello Barracks for the last time on his ill-fated tour of the south. In 1952 it was renamed for Cathal Brugha, who was a leader during the 1916 Rising, Minister for Defence in the first Dáil, and who lived locally for a time.

> He had a good slice of luck, Jack Mooney was telling me, and over that boxing match Myler Keogh won again that soldier in the Portobello barracks. By God, he had the little kipper down in the county Carlow he was telling me …
>
> (James, Joyce, *Ulysses*, Chapter 2, Lestrygonians episode)

Near the Grand Canal entrance to the barracks is the Garrison church, now called St Patrick's. This was built in 1842, but was rededicated for use by Catholics in the 1920s. In 1939, the renowned Irish stained-glass artist Evie Hone created the three-light window behind the altar, depicting the Good Shepherd with St Patrick and St Joseph. The original three windows were removed by the English army when they vacated the barracks in 1922.

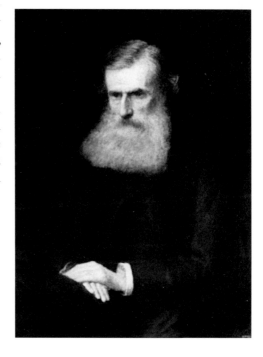

National Gallery painting of Fenian John O'Leary, painted by Jack B. Yeats. Both were Rathmines residents (Grosvenor Road and Charleville Road respectively). Courtesy of National Gallery of Ireland.

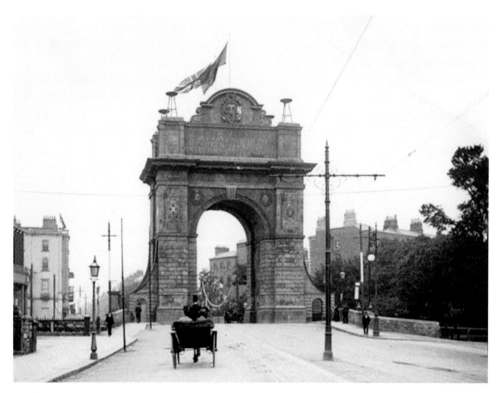

Leeson Street Bridge over the Grand Canal near Rathmines. Temporary ceremonial arch erected for the visit of Queen Victoria to Dublin, 1900. Note the variation of a Union Jack over the entrance. On arrival in Ireland, Her Majesty said, '"I am very pleased to find myself in Ireland once more.' At the magnificent structure at Leeson Street Bridge, the Athlone Pursuivant-at-Arms demanded entrance for the Queen. Advancing to the Lord Mayor, Athlone, said, 'Mr Lord Mayor of Dublin, I seek admission to the city of Dublin for her most gracious Majesty the Queen.' The Lord Mayor replied, 'On behalf of the city of Dublin, I desire to tender to the Queen a most hearty welcome to her Majesty's ancient city, and on the arrival of her Majesty the city gates shall be thrown open on the instant.' Loud cheers followed the demand and reply from the expectant crowds. Courtesy of NLI/Rathmines Heritage Society.

4

Ascendancy Connections: Lord Palmerston and the Cowper Temple Family

When one considers the names of many of the roads in Rathmines, one gets an inkling of the history of the area. Little reference to Ireland or Irish heritage, in fact. Names such as Palmerston, Windsor, Prince Arthur, Temple, Cowper, Grosvenor, Richmond, Bessborough, Cambridge, York, Maxwell and Belgrave dominate. There is even a Kensington Lodge. Rather, the emphasis was on England's history, politics and culture.

The mid-nineteenth-century English Prime Minister Lord Palmerston is remembered in the area, as are his family names, Cowper and Temple. The same is seen in local sport. Cricket, rugby, tennis and bowling were, and still are, the pre-eminent sports of the area. Consider the 'Kenilworth' Bowling Club, the 'Stratford' Lawn Tennis Club. Similarly, look at the number of Protestant churches and institutions in the area (such as the Rathmines School of Dr Benson and the Mageough Home).

Rathmines was then a strongly Protestant, unionist area, with a great attachment to the British monarchy. That the area established its own township illustrates its desire to be separate from the encroaching Catholic Irish. The southern unionists or loyalists had no intention of embracing an Irish identity. This was well captured by the famous Irish playwright, Seán O'Casey, who, in his The Plough and the Stars, and providing comic relief, had the "Lady from Rathmines" with the posh accent getting lost in the tenements of Dublin's city centre during the 1916 Easter Rising.

Palmerston Park, 1910. Courtesy of IHPC.

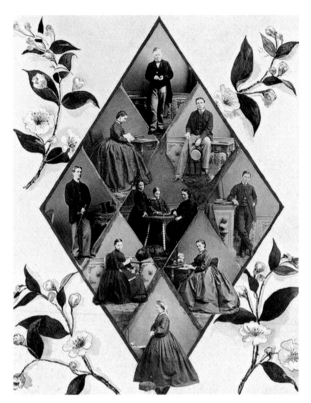

Diamond shape with nine studio portraits of the Palmerston family and a painted cherry blossom surround, from the Jocelyn Album (Countess Cowper), 1860s. The Temple/Lord Palmerston family inspired all Palmerston Road, Gardens, Temple Road, Cowper Road, etc., names. Like many others in this album, this page celebrates familial connection and continuity, with an interlocking diamond composition emphasising stability and permanence, even as dresses, shoes, and a sleeping dog spill into neighboring territory. Lady Jocelyn placed Prime Minister Lord Palmerston, her stepfather, at the top of the design, her mother, Lady Palmerston, at the base, and various children and grandchildren in between. British royalty were held in very high esteem by the many of the residents of Rathmines (e.g. Prince Arthur Terrace, Windsor Road, Grosvenor Road, Square/Road/Place). Courtesy of Arttatler/Archive Victorian Collage, National Gallery of Australia, Canberra/Rathmines Heritage Society.

Edward Arthur Henry Pakenham, 6th Earl of Longford, (29 December 1902, London-4 February 1961, Dublin), theatre patron and playwright who is best remembered as the director of the Gate Theatre in Dublin. He lived at Grosvenor Park, Leinster Road. Edward and Christine, the 6th Earl and Countess of Longford, founded Longford Productions in 1936. When the two-year-old Gate Theatre, founded by Micheál Mac Liammóir and Hilton Edwards, ran into financial difficulties in 1931, Lord Longford offered to buy the outstanding shares. The arrangement lasted until 1936, when, following disagreements, the company was divided in two, into Edwards-Mac Liammoir Productions and Longford Productions. Each company had six months in the theatre and six months touring. Longford Productions produced 151 plays at The Gate Theatre, during their twenty-four years of existence. They toured nationally and to London and enjoyed much success with plays by Denis Johnston, Bernard Shaw and others. Note the location of the Parnell Monument (an optical illusion?). Courtesy of NLI/The Gate Theatre.

All the borough councillors of the Rathmines township were unionist by inclination and supported unionist candidates in both the municipal and county council elections. There was no intention of power sharing with the nationalist population. Loyal addresses to members of the UK royal family were a common feature of local government at this time.

In unionist Rathmines there was never a question of a loyal address being opposed. This was not the case elsewhere. When the Town Hall officially opened in 1896, the building was festooned with Queen Victoria royalty decorations. Likewise, across the road, when the new Rathmines Library opened in 1913, a British flag hung over the entrance for some years. There was much weeping and gnashing of teeth with the changes ushered in by the successful fight for Irish Independence.

One of Rathmines' most prominent buildings is the Town Hall and its clock tower (designed by Sir Thomas Drew, completed in 1899). This building, now occupied by Rathmines College, once housed a town council for the Rathmines township, made up of local businessmen and other eminent figures. An Act of Parliament created the

Illustration depicting a maid and lady of the house in The Lady of the House, *1901. The three and four-storey houses of the wealthy in the Rathmines and Pembroke townships would have presented a formidable workout for those maids engaged in carrying the coals to the fireplaces on the various levels, beating rugs and carpets, and keeping the linen in order. Thousands were employed in the Rathmines area well into the twentieth century. Courtesy of Dublin City Public Libraries.*

Holy Trinity church, c.1954. Originally built in 1828, it has been modified and expanded over the years. It is a landmark structure, holding a pivotal position where a number of roads intersect. In Rathmines there are more Protestant churches (whether Church of Ireland, Anglican, Baptist, etc.) than Catholic, illustrating the social fabric and history of the area. Courtesy of Holy Trinity church.

Removal vans were a familiar sight in the Rathmines area in the early years of the twentieth century. Courtesy of Rathmines Heritage Society.

Rathmines Township in 1847, and its area was later renamed 'Rathmines and Rathgar', and expanded to take in the areas of Harold's Cross, Rathgar, Ranelagh, Sandymount and Milltown. The township was initially responsible only for sanitation, but its powers were extended over time to cover most functions of local government.

The township, with a population of 10,000, was created under the terms of the Towns Improvement Act. This followed a campaign by Rathmines developers, led by Frederick Stokes and Terence Dolan, and an inquiry held at 22 Rathmines Road. Rathmines then came under the control of a small number of businessmen with extensive property interests in the area. The town council determined building standards and byelaws and provided public services and amenities funded by rates. Lower rates in Rathmines encouraged development, which was initially along the main roads. The fields in between were developed later to a higher density, with smaller houses for the lower middle class and working classes.

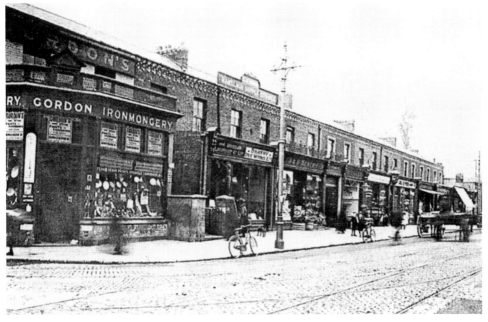

Ranelagh Road, near Rathmines in the 1940s. The Harcourt Street railway line (now the Luas) opened in 1854 and ran from Harcourt Street to Shankill. The Ranelagh/Rathmines station opened in 1896 and closed in 1958. Courtesy of Ranelagh Village.

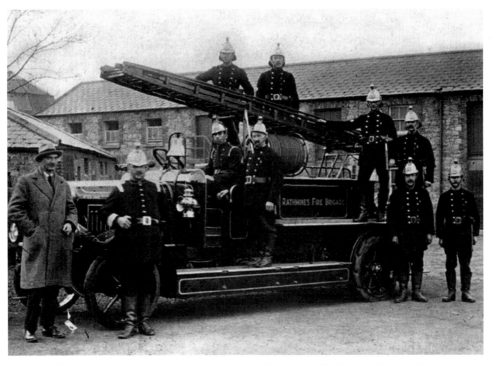

Rathmines Fire Brigade in the early years of twentieth century. Courtesy of Rathmines Heritage Society.

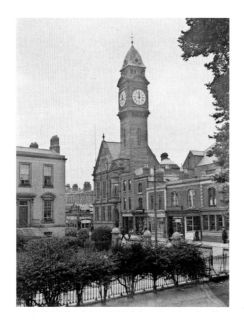

Tram passing the Town Hall in the late 1940s. Rathmines has thriving commercial and civil activity and is well known across Ireland as part of what is traditionally called a 'flatland' – providing reasonably priced accommodation to newly arrived junior civil servants and third-level students coming from outside the city from the 1930s to the present day. Courtesy of NLI/IHPC.

SCOTCH AND SHAMROCKS

In 1872, the tramway from Dublin to Rathmines opened. In the 1880s, Rathmines joined a major drainage scheme with the township of Pembroke. In the late nineteenth century, smaller terraces for lower and middle-class families were built, but the proportion of working-class families in the township remained small.

In 1903, Rathmines Borough Council introduced electric street lighting, with the opening of the Pigeon House power generating station. Standards in the main route were 9m 'Scotch Standard' and similar designs, generally with shamrock motifs. Carbon arc light fittings in a large spherical bulb were used until 1938. By 1911, the population had reached 37,840. These were predominantly Protestant and middle class, and occupied 7,050 houses.

WIGS AND FANS

The houses were built speculatively in the 1830s and '40s, on individual or groups of plots, giving rise to the groupings of houses. They were initially occupied as single residences by middle-class families, with service areas in the basements and stables in a mews to the rear. The houses are typically two bays wide and three-storey over a basement, the entrance elevated by a half level over a rendered basement. Columns or consoles in arched openings with leaded fanlights above flank the formal entrance doors. The service entrance is located under the entrance steps. The upper floors are faced with brick ranging from buff to reddish colour.

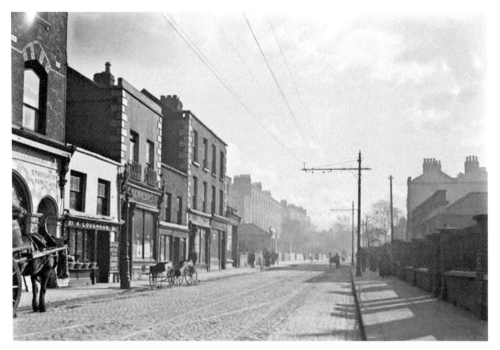

Upper Rathmines, c. 1898. Courtesy of NLI.

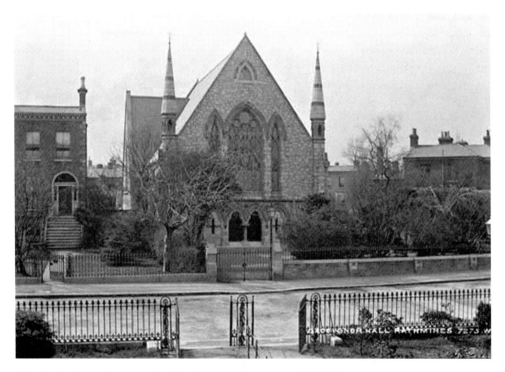

Baptist church on Grosvenor Road in the 1940s. Courtesy of HXHS.

All houses retain their original brickwork and a good proportion had original 'wigged' pointing of traditional lime mortar. The original windows are six-over-six paned sliding sash windows at each level. The roofs, concealed from view behind a parapet, consist of double-pitched slated roofs with a central valley and flashings of lead. Original rainwater goods are of cast iron. Front gardens form a semi-private defensible space to the public street, enclosed by decorative railings in a variety of types, with granite stones or plinth walls of exposed brickwork, capped with granite. Typical coach houses to the rear were originally small, two-storey structures, with simple pitched roofs.

The architectural style of the houses is derived from the typical Dublin townhouses of the eighteenth century. The external plainness of the houses is enriched by architectural features which add variety and decoration to the otherwise uniform and restrained design. The architectural detail is neoclassical in inspiration. Features such as door cases, porches, fanlights, door knockers, and, in particular, ironwork, are of great quality and diversity.

In addition to their aesthetic significance as works of architecture and urban design, the houses and buildings of Rathmines constitute an important historical document that contributes to our understanding of the past. The intact nature of Rathmines Road and other roads in the area provides us with physical evidence of nineteenth-century Dublin, and the first stages of suburban development outside the boundaries of the city in the period after the Act of Union, 1801. The houses and their contexts help us to understand the social and economic forces at play in mid-nineteenth-century Dublin and enable us to study how Rathmines developed.

Sisk & Son, Ireland's largest construction company. Having served a nine-year apprenticeship as a plasterer, John Sisk (b. 1837) set up his own business in 1859. That same year, he married Kate Burke and they went on to have six children. One of them, John Valentine (b. 1868), would go on to become an equal partner with his father and become a founder of John Sisk & Son Ltd. The first known contract was to build the Cork Distillery in 1868. In those early days many of the building projects were for banks and religious institutions – the sectors that had money. Working mainly in stone and timber, many churches, convents, schools and banks built by Sisk still stand today. Yet it was the third John Sisk who really grew the company on a national and international scale. After graduating as a civil engineer, he joined his father on the building of Cork City Hall in 1930 and moved to Dublin in 1937 to establish the company as a nationwide contractor. The family lived on Cowper Road, Rathmines, where John G. Sisk died. Photos show: 1. John G. Sisk with Taoiseach Jack Lynch; 2. one of Sisk's achievements; 3 the opening of Galway Cathedral, 1966. with President Éamon De Valera congratulating John G. Sisk. Courtesy of Sisk Group/Rathmines Heritage Society.

Rathmines Waterworks, c.1925. Courtesy of IHPC.

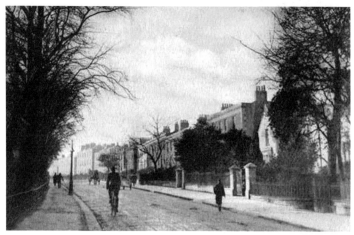

View of Leinster Road, travelling in the direction of Harold's Cross and away from the Town Hall, c.1906. Courtesy of Rathmines Heritage Society.

'MY SERVANT WANTS A RISE – HOW AWFUL'!

The borough of Rathmines had a unionist majority up to the late 1920s, when local government reorganisation abolished all Dublin borough councils. The last unionist politician to be elected from the borough was Maurice Dockrell (1850-1929). The township was incorporated into the City of Dublin in 1930 and its functions were taken over by Dublin Corporation, now known as Dublin City Council.

The increased cost of domestic servants and improved accessibility to more remote suburbs led the middle class to move away from the large houses of Rathmines. The practice emerged by which the large houses were subdivided into flats to accommodate students, civil servants and workers from rural areas moving to the city. 'Flatland' was born! Rathmines is still a local electoral area of Dublin City Council, electing four city councillors.

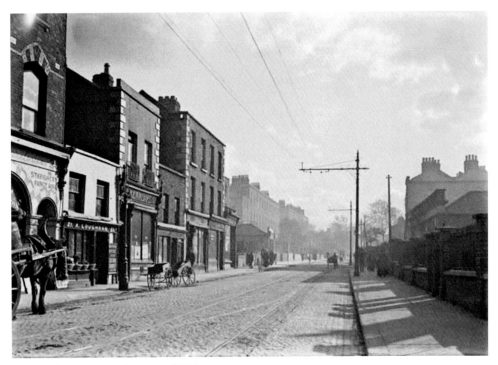

Upper Rathmines, c. 1898. Courtesy of NLI.

The Lodge at Rathmines Waterworks. Courtesy of IHPC.

5

The Rathmines Township

THE TOWN HALL AND THE CARNEGIE LIBRARY

Rathmines Library (1913), the Town Hall (1895/6), the post office (1934), the Kodak building (1931), the old YMCA (1911), Grand Canal House, the former TSB bank on the corner of Wynnfield Road and Rathmines Road, the Bank of Ireland branch opposite the Swan Centre, the former College of Commerce (now music school) and other fine buildings in the area, catch a visitor's attention. Likewise, buildings and structures off the main roads, such as the Mageough Residences on Cowper Road or the army buildings in Cathal Brugha Barracks. Moreover, the fine church in the grounds of St Louis High School in Charleville Road is another hidden gem. The curved terrace of houses at Bessborough Parade, lying in the shadow of the magnificent dome of Rathmines Catholic church is a similar treasure worth noting.

One of Rathmines' most prominent buildings is the Town Hall and its clock tower (designed by Sir Thomas Drew, completed in 1899). This building, now occupied by Rathmines College, once housed a town council for the Rathmines Township. The township was incorporated into the City of Dublin in 1930, and its functions were taken over by Dublin Corporation (Dublin City Council). Rathmines is still a local electoral area of Dublin City Council. The Town Hall's clock tower is a famous landmark in Rathmines.

Bank of Ireland's classic red-brick premises on Rathmines Road, with splendid external architecture and beautiful and ornate plasterwork within. Courtesy of Rathmines Heritage Society.

Designed by the Belfast-based architect Vincent Craig (brother of the first Prime Minister of Northern Ireland, Lord Craigavon) as a branch for the Belfast Banking Company, this later became part of the Trustee Savings Bank. A small building in a Scottish Baronial style, it turns a sharp corner with a corner turret. Courtesy of Rathmines Heritage Society.

The entrance to Rathmines post office. It was built in 1934 and the architect was William Cooke of the Office of Public Works. A quality building with Art Deco overtones, the post office (and formerly telephone exchange) in Rathmines is a much overlooked building at a very busy traffic junction. The doorway surround is particularly noteworthy. Courtesy of Rathmines Heritage Society.

Late-1960s picture of the former Archer's Garage in Rathmines. Courtesy of Rathmines Heritage Society.

Above left: *A selection of coal-hole covers in the Rathmines area. Notice the individual design of each. The covers were usually on the footpath outside the house and coal would be poured down to be retrieved in an underground coal-storage area by the maids and servants who were employed in many of the big houses of the area.* Courtesy of DCL/R&R HS.

Above right: *A selection of lampposts in the Rathmines area.* Courtesy of DCL/R&RHS.

Right: *The many varieties of post boxes in the Rathmines area.* Courtesy of DCL/R&RHS.

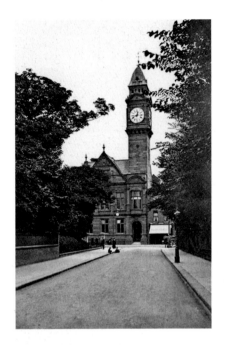

View of the Town Hall from Leinster Road. Leinster Road was the home of many famous people, including Countess Markievicz and Anna and Thomas Haslam. Courtesy of DCL.

In the nineteenth-century, some of the areas around Dublin City were called 'townships'. They were like small towns in themselves, each with their own Town Hall and town commissioners (nowadays these would be called councillors). The commissioners had to look after such things as lighting, water supply, sewage and drainage and the building of roads and houses. Rathmines had become one of these townships in 1847 and the Rathmines commissioners felt they needed a place where they could meet and conduct their business. Their first home was at 71 Rathmines Road, so it really became the first Town Hall.

In 1880, the nearby township of Pembroke built a new Town Hall. The Rathmines commissioners, who were very proud of the job they were doing in their area, thought they should have just as good a building – or an even better one.

Work on Rathmines Town Hall began in 1895 on the site of the previous town hall. The commissioners asked one of the best-known and respected architects of Ireland, Sir Thomas Drew, to design the building. He erected a fine building of red sandstone and brick with a bay window on the first floor. But the most famous feature was the high clock tower, which could be seen from afar.

Rathmines Technical Institute (later known as the College of Commerce) situated at the bottom of Leinster Road. It is now the DIT School of Music and is beside Rathmines Carnegie Library. Courtesy of Rathmines Library.

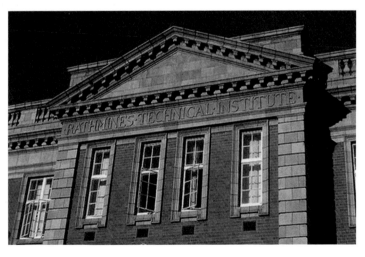

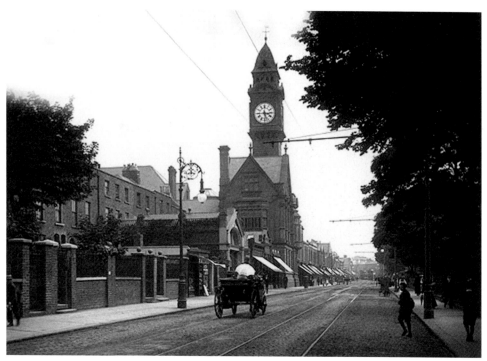

Rathmines Town Hall, c. 1910. Courtesy of DCL/Rathmines Heritage Society.

Rathmines Waterworks, c. 1920. Courtesy of IHPC.

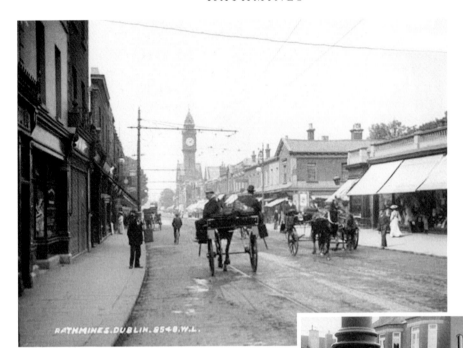

RATHMINES.DUBLIN.8548.W.L.

A busy Rathmines in the early 1920s. One of Rathmines' most prominent buildings is the Town Hall, with its clock tower. This building, now occupied by Rathmines Senior College, once housed a town council for the Rathmines township, made up of local businessmen. The Rathmines township was created by Act of Parliament in 1847, and its area was later expanded to take in the areas of Rathgar, Ranelagh, Sandymount and Milltown. The township was initially responsible only for sanitation, but its powers were extended over time to cover most functions of local government. Courtesy of NLI/IHPC.

Photograph of sewer vents with in the Rathmines area. Courtesy of DCL/R&RHS.

The clock on the tower was made by a local firm called Chancellor & Son. They claimed they could beat any English and Scottish company, so they got the job. The clock has four faces, one for each side of the tower. Before the clock could be run with electricity, the four sides would often show different times, so the clock was called 'four-faced liar'.

The Town Hall had a boardroom where the town commissioners would hold their meetings. There was also a gymnasium, a kitchen and a supper room (other people could hire this room out). There was an assembly hall for meetings, which could fit 2,000 people. It had a stage and room for an orchestra.

Apart from being used for council meetings, Rathmines Town Hall also became a centre for social life in the area, with concerts, dances and other events. Percy French, who wrote many well-known songs about counties in Ireland and who had his own theatrical company, gave many performances in the Town Hall and one of the first moving films, made by a man called Edison, was shown here in 1902.

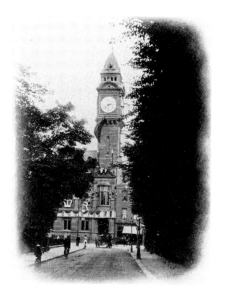

Earliest image of Rathmines Town Hall, festooned with regal decorations in 1896, just before its official opening. The symbols of the British monarchy, a crown and the letter 'R' signifying 'regina' or queen, are visible. On the opposite side of the crown would have been the letter 'V' for 'Victoria', as in Queen Victoria. The image is from a wonderful publication called Dublin and County Dublin, *which was published in 1908.* Courtesy of Dublin City Libraries Archives.

A hive of activity on Rathmines Road, c.1912. Courtesy of IHPC.

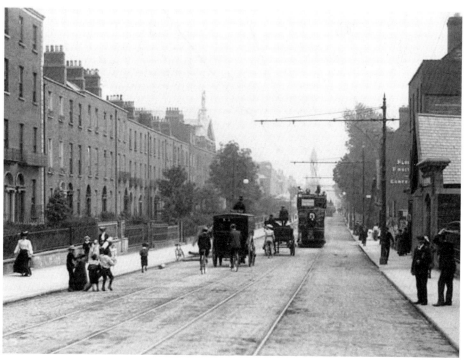

THE RATHMINES 'ORNAMENT' AND THE CARNEGIE CONNECTION

The Rathmines Public Library, which was built in the Baroque style in 1913, with Arklow terracotta brick and terracotta façade, is another one of the many stunning buildings Rathmines has to offer. Rathmines adopted the Public Libraries Act in 1887 to mark the Diamond Jubilee of Queen Victoria. Rathmines was the only authority in Ireland to do so, and lost no time in establishing a library committee. The first public library in Rathmines was opened in June 1887 at 53 Rathmines Road. It soon became very popular and needed more space. In 1899, it moved to 67 Rathmines Road, where it stayed for fourteen years, Rathmines Fire Brigade later used this building.

The lovely library that we know today was built with the aid of a £8,500 Carnegie grant. Andrew Carnegie was an American millionaire who gave money to build libraries and museums in America, England, Scotland, Wales and Ireland. One of his most famous buildings is Carnegie Hall in New York.

There was a competition to design the new library. Frederick Hicks won and the firm of Bachelor & Hicks of Dublin were the architects for the new building. The new library opened on 24 October 1913.

Newly opened Rathmines Library, c.1913. Courtesy of DCL.

The library was built using Carlow red brick and was designed to fit in with the style of the Town Hall. It was intended to be an 'ornament to the township'. The library and technical school next door were part of the same building but each had a separate entrance. The entrance to the library is flanked by two-storey-high Ionic columns. A large, stained-glass window is located above the entrance. A ventilating cupola is located on the centre of the roof. Large Venetian windows provide light to the ground floor. The interior retains a fine staircase to the first floor, which divides into two parallel flights.

The library had a lending department where people could borrow books and a reference library where they could sit and read. It also had a special room where people could come to read the newspapers each day. This was a large, sunny room on the ground floor where it was pleasant to read. Newspapers were expensive for ordinary people in those days, so people looked up the news and the jobs pages in

Leeson Street Bridge over the Grand Canal near Rathmines, with temporary castle entrance during the visit of Queen Victoria to Dublin in 1902. Courtesy of DCL.

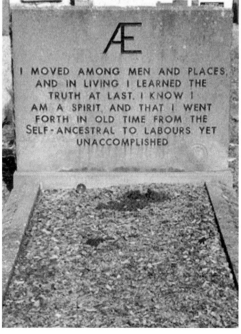

The headstone of George Russell in Mount Jerome Cemetery. Former resident of Grosvenor Square. George William Russell (10 April 1867-17 July 1935), who wrote under the pseudonym Æ (sometimes written AE or A.E.), was an Irish nationalist, writer, editor, critic, poet, and painter. He was also a mystical writer, and centre of a group of followers of theosophy in Dublin for many years. Courtesy of Mount Jerome Cemetery.

*The headstone of writer and poet William Carleton (1794-1869)
in Mount Jerome Cemetery. A literary figure of the mid-Victorian
period who dealt with a traditional native Irish theme, Carleton began
his literary career as a poor Catholic scholar but later converted to
Protestantism and wrote* Traits and Stories of the Irish Peasantry,
The Lough Derg Pilgrim *and the poems 'The Midnight Hour' and
'The Priest's Funeral'. Carleton continued to write until his death
in Rathmines, on 30 January 1869.* Courtesy of Mount Jerome/
Rathmines Writers' Workshop.

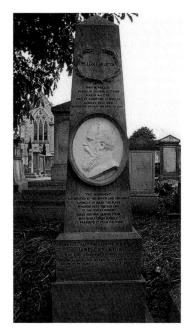

the library. A feature of note within the building is
the stained-glass window, which depicts a figurative
allegory of literature. Designed by William Morris, it
is situated halfway up the beautiful double staircase.
Morris was a famous English artist and designer of beautiful furniture and fabrics.

The library is a protected structure under the provisions of the Local Government
Planning and Development Act 1999 and is considered to be of national importance.

In the beginning there was no children's library. Mary Kettle, a councillor in
Rathmines, and other female councillors were very interested in making poor
children's lives better. They voted to provide school meals to make sure that children
were not hungry. They also supported the opening of a children's library in Rathmines
and this happened in 1923.

The library holds the only surviving plaque from the Princess cinema. This cinema
was opened as the Rathmines Picture Palace on 24 March 1913, just a few months
before the library opened. It is not there now, as the building was sold in June 1981 and
demolished in 1982.

According to Séamas O'Maitiú in his book *Dublin's Suburban Towns 1834-1930*:

> … under the Library Acts it was not necessary for members of library
> committees to be councillors and such bodies in Ireland were noted for
> their clerical representation. This was the case in Rathmines where local
> clergymen were seldom absent from the library committee. Reading
> material was closely vetted and the committee felt obliged occasionally to
> censor the material made available to the readers.

He noted that the committee had instructed the librarian to 'expunge as far as possible
all sporting news relating to horse racing from the newspapers provided for the public
in the library'.

Halfway up the beautiful double staircase in Rathmines Library is a stained-glass window with the word 'Literature' on it, which was designed by William Morris. Morris was a famous English artist and designer who designed beautiful furniture and fabrics. Courtesy of Rathmines Library.

Cover of a 1958 book co-edited by Donagh MacDonagh and Lennox Robinson. Poet, dramatist and lawyer Donagh MacDonagh was the son of the 1916 signatory Thomas MacDonagh. He lived at 9 Palmerston Road, Rathmines. His grandmother was Muriel Gifford, one of the four Gifford sisters of Temple Villas, Rathmines. Grace Gifford married another of the 1916 signatories, Joseph Mary Plunkett. Courtesy of Whyte's/HXHS/ Rathmines Heritage Society.

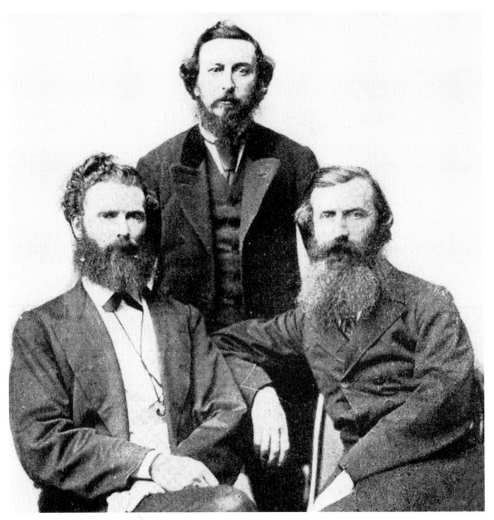

John O'Leary (23 July 1830-16 March 1907) was an Irish poet and Fenian. This image shows Denis Dowling Mulcahy, Thomas Clarke Luby and John O'Leary (right), resident of Grosvenor Road, Rathmines. Courtesy of HXHS.

6

A Refuge for Saints and Sinners

Another well-known landmark of Rathmines is the prominent copper dome of Mary Immaculate, Refuge of Sinners church, which dominates the skyline. The original dome was destroyed in a fire in 1920 and replaced by the current dome when the church reopened in 1922. The dome was to be used in St Petersburg but the political and social upheaval there caused it to be diverted to Dublin.

The story of the church began when Archbishop Daniel Murray officially constituted the parish of Rathmines on 12 December 1823 and appointed Fr William Stafford the first parish priest. The districts of Rathmines and Rathgar had hitherto formed a section of Parish of St Nicholas Without, Francis Street.

The issue of where the parish church should be constructed was crucial. At that time, the entire stretch of land extending from the canal along the left-hand side of Rathmines Road as far as Richmond Hill had no buildings on it. Two acres, two roods and thirty-eight perches were purchased from the owner of the land, the Earl of Meath, in 1824. It was upon this site the foundation stone for the new Catholic church was laid by Lord Brabazon, heir to the Earldom of Meath. This Gothic church measured ninety feet long by thirty-seven feet wide, with a height of thirty-seven feet. It cost approximately £5,000 and it took five years to build, due to settlement problems with one of the walls. Archbishop Murray consecrated this first church under the protection of St Mary and St Peter on 15 August 1830. Some of the land originally purchased was eventually sold to obtain funds to finish the interior of the church.

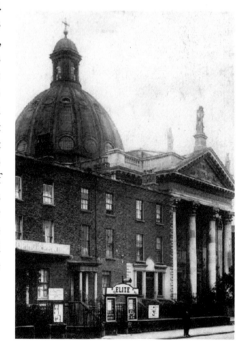

Dome of Rathmines church, 1916. Courtesy of NLI/ DCL.

By the middle of the nineteenth century, the development of the city and the consequent increase in the Catholic population of Rathmines necessitated enlargement of the church.

In July 1848, a visiting missionary priest, Fr Gentili of the Order of Charity, described some beautiful churches he had observed in Italy and called for the building of a new church in Rathmines. In September of that year, a public meeting was held to discuss the proposition to build a bigger church. It was decided to retain the existing location, with the church facing the main Rathmines Road. On 18 August 1850, Archbishop Murray, accompanied by the Bishops of Dromore and Down and Connor, who were on their way to the Synod of Thurles, laid the foundation stone of a new church. The church was to be built to the Byzantine model in the form of a Greek cross, the first such construction in the Archdiocese of Dublin since Catholic Emancipation (1829).

Patrick Byrne designed the new church, constructed around the original building. John Lynch (of Mount Pleasant Avenue) did the masonry work, the stone originating from quarries at Kimmage and Donnybrook. The granite was obtained from Ballyknocken. William Hughes (of Talbot Street) was responsible for the roof and the dome. Messrs Hogan and Connolly (of what is now Pearse Street) executed the plasterwork.

In 1856, the church was completed, with the exception of the portico, and was dedicated by Archbishop Cullen on 19 June. It was a truly impressive occasion, with sixteen bishops and 200 priests present at the ceremony.

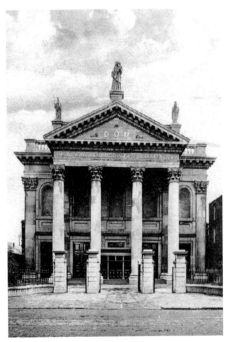

Front of Rathmines church in the 1940s. Courtesy of NLI/DCL.

Architects interior of Rathmines church, 1855. Courtesy of Rathmines church.

Interior of Catholic church, Mary Immaculate, Refuge of Sinners, Rathmines. Courtesy of Catholic Parish of Rathmines.

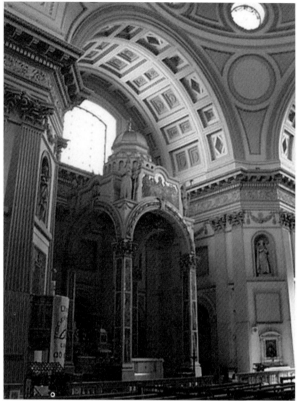

St Mary's National School, Richmond Hill (not Redmond's Hill), 1930s. Adjacent to the church of Mary Immaculate, Refuge of Sinners, Rathmines. Courtesy of Mountallant/Memories of Rathmines/Dublin.ie/ DCC.

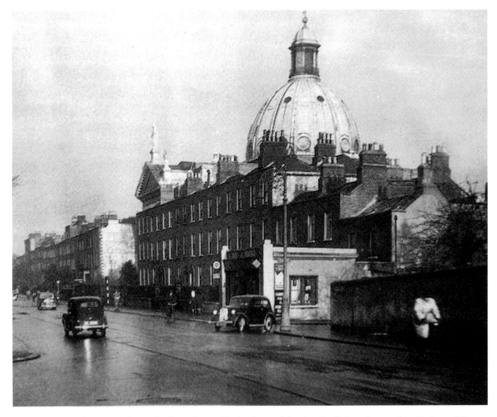

Rathmines Road on a wet day in the late 1940s, with the dome of the church of Mary Immaculate, Refuge of Sinners in background. Courtesy of Damntheweather/Dublin.ie/DCC.

The year 1878 saw work begin on the erection of the magnificent portico, with its four massive columns and their carved Corinthian capitals surmounted by a beautiful pediment. The portico, except for the wings, was completed in 1881, the twenty-fifth anniversary of the church. The statue *Our Lady of Refuge* was taken from the central niche of the façade and raised to the eminent position it now occupies the apex of the pediment. This statue, a work by James Farrell, was shown at an exhibition in Dublin in 1853 and purchased by Fr Collier, a curate in the parish. The statues of St Patrick and St Laurence O'Toole were then placed at the extremities of the portico.

The portico was erected from Portland stone. The contract was given to local builders Meade & Son under the direction of architects O'Neill & Byrne – also parishioners.

The letters DOM written in gold on the façade stand for the Latin '*Deo Optimo Maximo*' and underneath are the words '*Sub Innov. Mariae – Immaculatae Refugi Peccatorum*': 'Dedicated to God the Most High under the invocation of Mary Immaculate, Refuge of Sinners'.

Front view of Mary Immaculate, Refuge of Sinners Catholic church, Rathmines. Courtesy of Catholic Parish of Rathmines.

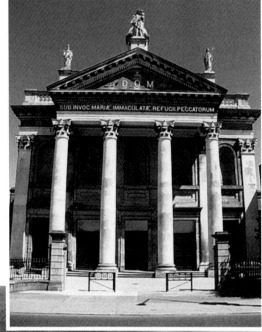

Burning of Rathmines Catholic church and collapse of the dome, 1920. On 26 January 1920, the sacristan arrived to open the church for the 7a.m. Mass only to discover that the switch panel was on fire. He raised the alarm but the whole front of the altar was already in flames. The fire spread quickly along the electricity wires and Canon Fricker was forced to watch helplessly as flames devoured the church. At 9a.m. the dome collapsed, crashing to the ground with a sound that was heard for miles around. Only the shrine of Our Lady of Perpetual Succour and the sacristy escaped damage. Courtesy of IHPC/ Rathmines Parish.

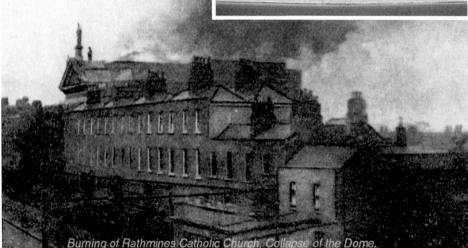

Burning of Rathmines Catholic Church, Collapse of the Dome.

THE TRAGIC FIRE OF 1920

On 26 January 1920, the sacristan arrived to open the church for the 7 a.m. Mass to discover that the switch panel was on fire. He raised the alarm but the whole front of the altar was already in flames. The fire spread quickly along the electricity wires and Canon Fricker was forced to stand and watch helplessly, as flames devoured the church. At 9 a.m. the dome collapsed, crashing to the ground with a sound that was heard for miles around. Only the shrine of Our Lady of Perpetual Succour and the sacristy escaped damage.

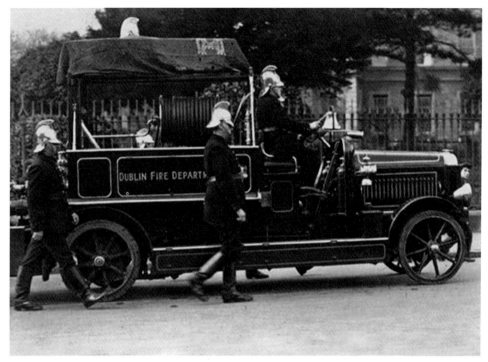

Dublin Fire Brigade in action, c. 1908. Rathmines had its own fire station, next door to the Town Hall. The Dublin local history writer Eamonn MacThomáis was born adjacent. His father was captain of the Rathmines Fire Brigade. Courtesy of NLI.

A local fireman, Jeremiah Lawlor, of the Rathmines Fire Station sustained a fractured rib as he attempted to contain the fire. As news of the fire spread, Archbishop Walsh and Alderman William T. Cosgrave (later President of the Executive of the Irish Free State and leader of Cumann na nGaedhael) of Dublin Corporation called during the day to offer sympathy to the parish priest.

The next day, a heavy gale damaged two stained-glass windows valued at £1,000. The following week, on 5 February 1920, a public meeting to discuss the rebuilding of the church was held in the Mansion House. The Lord Mayor presided and those present included the Archbishop, the Lord Chief Justice and members of Dublin Corporation.

The architect R.H. Byrne was subsequently commissioned with the task of rebuilding the church. In a short time, the debris was removed and the restoration work began in earnest. A temporary roof was erected. The walls, although badly damaged, were found to be structurally sound, but the interior required considerable refurbishment. The facade was relatively intact. The cost of repairs was estimated at £35,000 but ultimately came to £55,000.

Reconstruction began immediately, and was sufficiently advanced to enable the church to be reopened after five months on 4 July 1920. The outstanding feature of the reconstructed church was the dome. The previous dome, which was completely

destroyed in the fire, was replaced with a large copper dome that had been built in Glasgow some time previously. It was believed to have been destined for a Russian Orthodox church prior to the Revolution of 1917.

Many present and former parishioners will remember the Rathmines Folk Group, which was founded in 1972. Since they began singing together all those years ago, not one six o'clock Mass in Rathmines has been without the group.

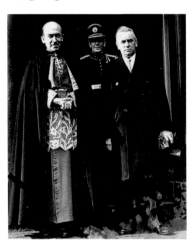

Taoiseach and local TD for Rathmines area, John A. Costello, with Dublin's Archbishop John Charles McQuaid. He declared the Irish Republic, led the country's first coalition government, and faced the Mother and Child Crisis. A surprise choice who battled against taking the job, Costello was the 'Reluctant Taoiseach'. Other famous TDs for this constituency include: Dr Noel Browne, former Taoiseach Garrett Fitzgerald, and Seán MacEntee. The constituency was created under the Electoral (Amendment) Act 1947 and first used at the 1948 general election. By geographical size, it is the smallest constituency in the country. Courtesy of HXHS/Rathmines Heritage Society.

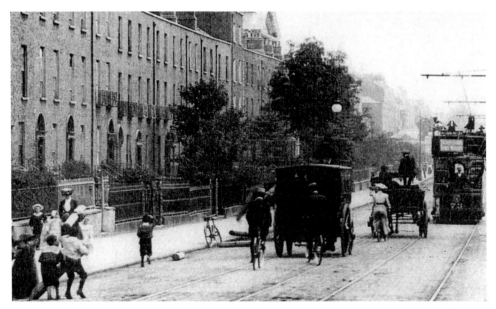

Children playing on Rathmines Road at end of the nineteenth century. These are well-dressed children, quite unlike much of the rest of the Dublin populace, who had to contend with poverty and appalling living conditions. The houses on the left would have been owned by the gentry, whereas in Dublin city centre, similar houses (Georgian) would have each contained upwards of 100 adults and children, i.e. a family of twelve would have lived in one room. Of the 5,000 Catholics who worked in Rathmines in the late-nineteenth century, only 300 could have afforded to live there. Courtesy of IHPC/HXHS/Rathmines Heritage Society.

The church of Mary Immaculate, Refuge of Sinners, was built in 1854 'in the Greek style' by Patrick Byrne and later extended by W.H. Byrne, who added the portico and pediment. This pediment is inscribed 'Mariae Immaculatae Refugio Pecatorum'. *It was destroyed by fire in January 1920 but it was rebuilt by 1922. Another well-known feature is the prominent copper dome. The original dome was destroyed in the fire in 1920 and replaced by the current dome when reopened in 1922. The dome was to be used in St Petersburg, but the political and social upheaval in this city caused it to be diverted to Dublin.* Courtesy of Rathmines Catholic church of Mary Immaculate, Refuge of Sinners.

Interior of the landmark dome of Catholic church, Mary Immaculate, Refuge of Sinners, Rathmines. Courtesy of Catholic Parish of Rathmines.

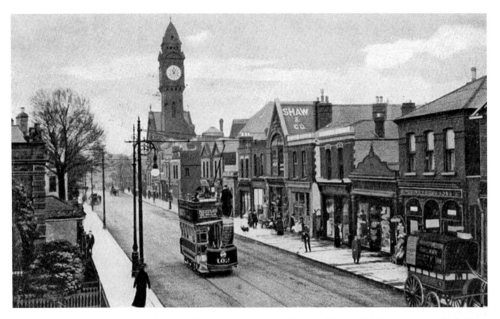

Rathmines Road, with an open-top tram making its steady way to Nelson's Pillar in O'Connell Street. Notice the passenger ascending to the upper deck. Courtesy of NLI.

CHALLENGE TO THE ASCENDANCY

The Church of Mary Immaculate, Refuge of Sinners is an important later work of Patrick Byrne, the leading architect of Catholic neoclassical churches in post-Catholic Emancipation (1829) decades. The church rates as one of Byrne's masterworks and can be considered of national architectural significance.

As a particularly ambitious example of Catholic church-building, it is of historical significance as a document of social change, demonstrating the emergence and increased confidence of a Catholic middle class in the latter half of the nineteenth century, in what was a bastion of Protestant and unionist influence and control. The church is therefore of particular historical significance, illustrating the challenge to the Protestant establishment by an increasingly confident Catholic population.

THE SINGING PRIEST

The 'Singing Priest', Fr Michael Cleary lived at Mount Harold Terrace, Leinster Road for a number of years, until his death in 1993. He was a renowned radio and television personality as well. A charismatic and powerful figure in the Catholic Church, he presented a late-night radio phone-in show in Dublin in the 1980s and hosted his own television chat show. He was nicknamed 'The Singing Priest' after he released two albums of songs. He achieved more notoriety after his death, when it was revealed that

'The Singing Priest'. A young Fr Michael Cleary. Cleary (1944-1993). Courtesy of RTÉ/ HXHS.

Chain-smoking Fr Michael Cleary. Fr Cleary, 'The Singing Priest', lived the last years of his life at Mount Harold Terrace, Leinster Road, Rathmines. This photograph was taken with members of the Ballyfermot Peace Corps when he was parish priest in Ballyfermot, Dublin. He was also famous as a chain smoker. Courtesy of Ballyfermot Parish/HXHS.

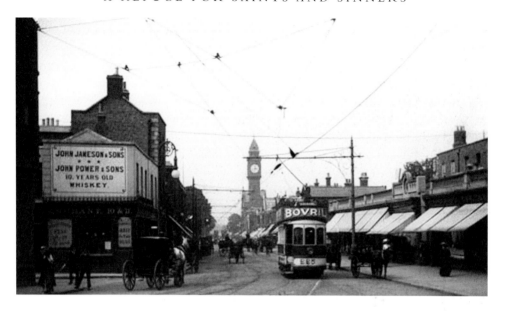

Busy junction on Rathmines Road, c.1910. Courtesy of IHPC.

Shining a light on a dark past. Pages of the Rathmines News and Dublin Lantern *reveal the frequency with which newborn babies, both dead and alive, were found at the end of the nineteenth century.* Courtesy of *The Irish Times,* 29 October 2010.

he had lived with a woman and fathered two children with her, while she acted as his housekeeper. They lived as a family in secret.

He was strongly devoted to care for the poor and working on poverty and community development issues. In the 1960s, Fr Cleary discussed the Catholic clergy's attitudes to celibacy, sex and marriage in the Irish documentary film *Rocky Road to Dublin* (1967). He admits to a personal preference for being married and having a family, but claims the role and necessary sacrifices of being a priest are a valid substitute. As part of his pushing limits, he once claimed to have tried every drug except heroin. Fr Cleary had one of the highest profiles of any cleric in Ireland throughout the 1970s and 1980s.

NOTORIOUS MURDER TRIAL OF MAMIE CADDEN

Mary Anne 'Mamie' Cadden (b.27 October 1891, Pennsylvania, USA; d.20 April 1959, Dublin, Ireland) was an Irish midwife, backstreet abortionist and convicted murderer. Cadden was born in America to Irish parents from County Mayo. Her family returned to Ireland in 1895 after Mamie's father inherited his father's farm. In 1925, she moved to Dublin to train as a midwife at the National Maternity Hospital, Holles Street. In 1931 she purchased a property in Rathmines (opposite the Swan Centre) and ran it as her own maternity nursing home. This was a common practice among midwives at the time, as their profession operated independently of nursing and medicine.

As well as delivering babies, at a fee Mamie Cadden also passed on unwanted babies to an informal fostering service, which placed them with families who received payment for caring for the child. She also provided abortions (both medical and surgical), which were and remain illegal in Ireland.

'Nurse Cadden's' activities were an open secret, and since all forms of contraception and abortion were forbidden, many women wanted to use services such as those Cadden had to offer. Her nursing home in Rathmines came to an end in 1939 when she was sentenced to a year's hard labour in Mountjoy Prison for abandoning a newborn baby on the side of the road in County Meath. She had to sell the property to pay her legal fees.

Once out of prison, she set up business again. She no longer delivered babies, but continued to provide abortions and miscellaneous medical treatments such as cures for constipation and dandruff. In 1945, a pregnant girl who needed hospitalisation after a failed abortion blamed Cadden. Cadden was tried under the Offences against the Person Act 1861 and sentenced to five years' in Mountjoy Prison.

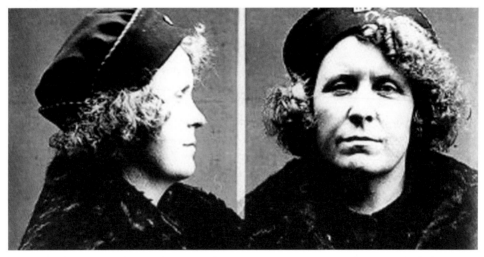

Photograph of Nurse Mamie Caden (1938), whose abortion activities caused an outcry in 1950s Ireland. She ran a nursing home at 183 Lower Rathmines Road, opposite the Swan Centre. Courtesy of HXHS/Rathmines Heritage Society.

On her release, after serving the full term, she set up her business once again, this time in Hume Street. Cadden was still well enough known and did not to need to advertise. In 1951, one of her patients died from an air embolism in the heart and Cadden just put the body outside on the street, and even that did not put an end to her activities, as there was not sufficient evidence to connect her to the death. Five years later, however, she was not so lucky. Another patient, one Helen O'Reilly, died of an air embolism during a procedure to abort a pregnancy in the fifth month. When her body was found on the pavement in Hume Street, Cadden was arrested and tried for murder. She was sentenced to death by hanging in 1956, but this was commuted to life imprisonment after public appeals for clemency and due to the unintentional nature of the death. Cadden started serving her term in Mountjoy Prison, but was declared insane and moved to the Criminal Lunatic Asylum in Dundrum, where she died of a heart attack in 1959. Cadden and her controversial activities are the stuff of Dublin legend.

ST MARY'S SCHOOL: FROM STABLES TO CLASSROOMS

On 25 July 1887, the General Council of the Holy Ghost Fathers meeting in Paris gave its approval for the establishment of a secondary school in Rathmines. The plan was delayed by two factors – lack of available personnel and the difficulty in obtaining a suitable site. On 11 April 1890, the decision was made to begin the project of founding a day school in Dublin 'without delay'. On 27 July, Fr Jules Botrel – the Provincial Superior – was able to write with evident relief 'We shall take possession of Larkhill [the present St Mary's] after tomorrow at midday.'

Larkhill was originally built in 1841. It was later rented and then bought by Mr James Walker, a Quaker. Fr Botrel bought it for £2,000. Adapting it for the first intake of students on 8 September 1890 cost another £1,000. In a letter, Fr Botrel informed the Superior General that:

> … the alterations at Larkhill are well advanced. For £500 we have transformed the stable and coach-house into two fine classrooms; we have changed the courtyard into a magnificent assembly hall with a glass roof. This will be the centrepiece of future buildings. The £500 includes the building of an office and ten toilets.

A nearby house at 13 Leinster Square was rented to house the Community temporarily.

The first Superior and President of the College was Fr Thomas Fogarty. In 1896, Fr Fogarty reflected, 'Our students are not yet perfect. It cannot be said that they show an excessive enthusiasm for study! … and yet in spite of everything we managed to succeed in the examinations at the end of the year.'

But numbers began to fall from the beginning of the war in 1914, and were down to 140 in 1916. In July 1916, a formal decision of the General Council in Paris closed St Mary's after an existence of twenty-five years. After the closure of the school in 1916

the buildings were turned over for the use of the philosophy students from Kimmage, and the provincial administration and mission promotion work. Fr J.C. McQuaid (John Charles McQuaid, the future and long-serving Archbishop of Dublin) and others were ordained in the college chapel. When the parish church burned down in 1920, the parish availed of the Provincial's offer to use the school hall for parish Masses. However, the school reopened in 1926.

During the Presidency of Fr Tom Maguire (1945-51), nearby Kenilworth Square was acquired fortuitously and a private park was quickly transformed into rugby, cricket, tennis and basketball areas. Past-pupil brothers and Dublin diocesan priests, Frs Tom and Ernest Farrell, founded the Catholic Boy Scouts of Ireland in 1927. The new chapel, visible from the main Rathmines Road was completed in 1955. Being faithful in difficult circumstances (*Fidelitas in Arduis*) remains a realistic motto for this school, as it is for life itself.

ST LOUIS HIGH SCHOOL: FROM ONE RULER TO ANOTHER

St Louis Convent School was founded by the Sisters of St Louis, whose aim was to provide Christian education in a changing world. It opened on 1 September 1913 in 'Charleville', originally the residence of Sir John Grey, Lord Lieutenant of Ireland.

St Mary's School, now a Gospel Hall, on Upper Rathmines Road. Courtesy of Rathmines Heritage Society.

From the convent house, the school expanded in 1929 with the purchase of a nearby property, 8 Grosvenor Road, and in 1942 the property next door at 7 Grosvenor Road was acquired. A concert-hall wing and twelve classrooms were added in 1950. In 1965-6 a gym and six new classrooms were added on to the school and a new convent chapel was opened. The introduction of the Free Education Scheme in summer 1967 led to rapid expansion of enrolments. A new school was built, which was opened in 1982.

THE DEVIL IN THE DETAIL: THE ST LOUIS CREST

The St Louis Crest is an absolute fount of information. The blue field represents the Kings of France. St Louis was King Louis IX of France (1214-1270). '*Dieu Le Velt*' was the rallying cry of the Crusaders – 'God Wills It'. St Louis went on two Crusades to the Holy Land 1242, in thanksgiving for his recovery from a serious illness. In 1270 he went to Tunis, where he hoped to make Christ known to the Muslims. He became ill and died there. His body was brought back to France and his heart was buried in the Benedictine Monastery at Palermo. The fleur-de-lys is the symbol of the Kings of France. It represents the country of origin of the Sisters of St Louis.

The tower, with red hand, is part of the Monaghan coat of arms. Monaghan was the town in Ireland to which the first Sisters came from France on 6 January 1859. The crown of thorns and sword relate to St Louis bringing Christ's crown of

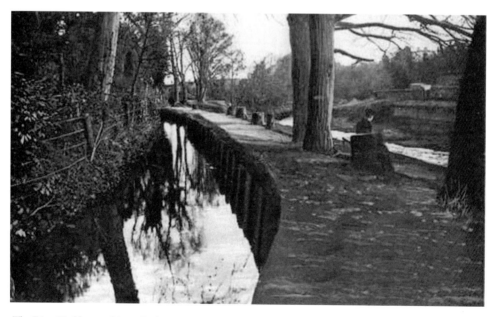

The River Dodder near Upper Rathmines, c.1927. There were a number of mills dotted along the Dodder, including the Dartry Dye Works and the Dublin Laundry. A tributary of the Dodder, the Swan, winds its way under Rathmines and gives the name to the Swan Centre. Courtesy of NLI/Rathmines Heritage Society.

thorns to France for safety. It had been saved during the First Crusade. The golden chain symbolises the bond of Christian charity which unites all the members of the congregation, and which also links them to those with whom they carry out their ministries in schools, colleges, hospitals and parishes. It is echoed in the second motto '*Ut Unum Sint*' ('That they may be one'), while the primary motto, '*Dieu le Veult*' inspires acceptance of the ups and downs of life that we meet with every day in carrying out our work for God.

7

Trams and Barges

From the 1850s, horse-drawn omnibuses or trams provided transport from Rathmines to the city centre. Portobello Bridge, which had a steep incline, was often a problem for the horses, and led to the fatal accident of 1861. One evening, when a gale was blowing, the omnibus or coach that plied between Rathfarnham and the centre of Dublin (via Rathmines) was blown into the canal; many people were injured and a Mr Gunn was killed. On 6 October 1871, work commenced on the Dublin tram system on Rathmines Road, just before Portobello Bridge, and a horse-drawn tram service was in place the following year. The following year also saw the long-awaited (since the 1861 accident) improvements to Portobello Bridge carried out, the Tramway Company paying one third of the total cost of £300.

From the 1850s, horse-drawn omnibuses provided transport along South Richmond Street from Rathmines to the city centre. On 6 October 1871 work commenced on the Dublin tram system on Rathmines Road, a few yards from Portobello Bridge They came into operation the following year, linking Rathgar, via Rathmines, with College Green. There was just one standard fare within the city limits, which was much cheaper than the old horse-drawn omnibuses.

Dublin tramways commenced line-laying in 1871 and began service in 1872. At its peak, with over sixty miles of active line, the system was heavily used, profitable and advanced in technology and passenger facilities, with near-full electrification complete from 1901. Heavy usage lasted from the late nineteenth century into the 1920s. The tram system was also central to the Dublin Lockout, which caused major distress within the city. The last trams ran on 9 July 1949 in Dublin city and in 1959 on Howth Head.

Rathmines and Ranelagh tramway station opened on 16 July 1896 and finally closed on 1 January 1959. Tramway House is still standing in upper Rathmines, just before you come to the Dartry Dye Works. The word 'tram' still lives on in the area, including Tramway Cottages and the Tramco bar. Rathmines is now served by the Luas light rail system, the Cowper stop on the Green Line being within a short walking distance from Cowper and Palmerston Road. The Charlemont stop is also nearby, along by the Grand Canal. And, instead of the No.15 tram, the No.15 bus now serves the area.

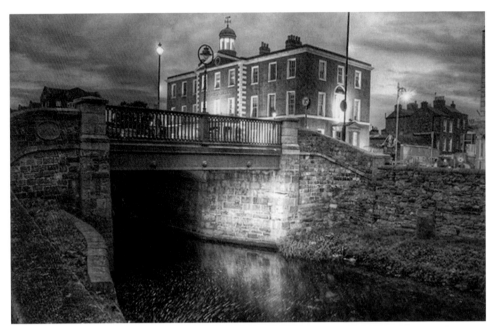

A view of Portobello (Latouche) Bridge (1791) over the Grand Canal, linking Rathmines with the city centre.
Courtesy of Rathmines Heritage Society.

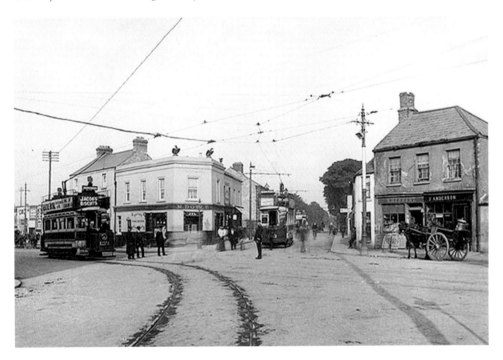

The No. 16 tram (left) coming from O'Connell Street via Harold's Cross and the No. 15 tram (centre) coming via Rathmines at Terenure Cross, c. 1900. The line in the foreground connected with the D&BST's Terenure depot. It was used at night to transfer goods between the two systems. Courtesy of IHPC/DCL.

THE 1913 LOCKOUT

In 1913, the labour movement in Dublin engaged in head-on confrontation with their employers – often simplified in the persons of James 'Big Jim' Larkin, founder and leader of the Irish Transport and General Workers' Union (ITGWU), and businessman William Martin Murphy, the main force behind the Dublin Employers' Federation Ltd. He managed one of Dublin's famous department stores, Clery's in O'Connell Street, and owned the nearby Imperial Hotel. In 1905 he relaunched the *Irish Independent*, which soon became the bestselling Irish nationalist daily newspaper. He was president of the Dublin Chamber of Commerce.

The ITGWU, formed in 1909, had 10,000 members. The employers, hit by strike after strike across the city, had tried to handle them individually, but by 1911 Murphy had had enough and formed a federation to break the ITGWU once and for all.

Murphy refused to recognise the ITGWU, would not talk with anyone who was a member, and, in July 1913, called a meeting of his employees in the Tramways Company, where he bluntly told them that, while they could form a union of their own, they could not join the ITGWU. Tram workers deserted their vehicles in protest.

On 21 August, about 100 of the workers in the Tramways Company received their dismissal notice, 'As the Directors of the Tramways Company understand that you are a member of the ITGWU whose methods are disorganising the trade and business of the city, they do not further require your service.'

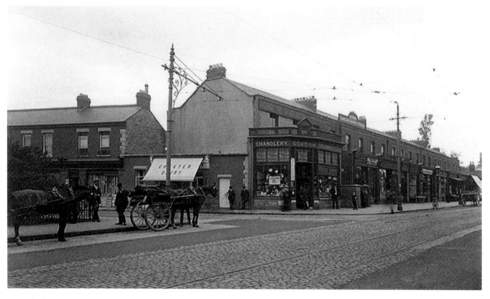

Ranelagh village near Rathmines, c.1920. In 1768, William Hollister opened the Ranelagh Pleasure Gardens as a place of entertainment for the well-to-do of Dublin. Richard Crosbie ascended in a balloon from the gardens in 1785. Courtesy of Ranelagh Village.

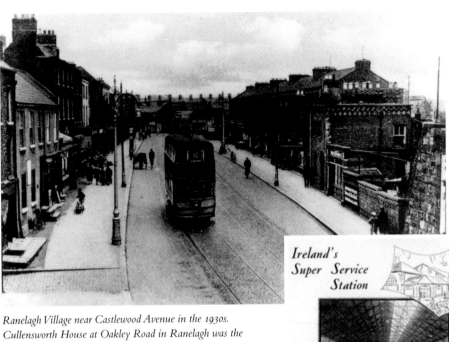

Ranelagh Village near Castlewood Avenue in the 1930s.
Cullensworth House at Oakley Road in Ranelagh was the
birthplace of William Lecky (1838-1903), famed historian.
The house was later bought by Patrick Pearse for his school 'St
Enda's'. Two years later, the school moved to Rathfarnham, and
Cullenswood House became a bilingual school for girls, 'St Ita's',
until 1912. Courtesy of Ranelagh Village.

Ireland's
Super Service
Station

A garage without an equal any-
where in Ireland. In size,
colossal—palatial in appear-
ance. Designed with special features
that combine to give the Irish
motorists infinitely better service.
The floor space is immense; the
entrance and exit are conveniently
wide. The mechanical equipment
of the garage includes all the most
modern apparatus for cleaning and
overhauling cars efficiently and
speedily. Repairs to all makes
of cars are carried out by a skilled
staff and at competitive prices.

This model service station is equip-
ped with comfortable waiting rooms
for ladies and gentlemen, and wash-
ing conveniences, too. It also boasts
a telephone kiosk. These are all
especially for the use of clients
and their friends.

A 1932 advertisement for Brittain Motors on Grove Road,
Rathmines. The motor plant was located along the Grand
Canal until the 1980s. Next door was Taylor's Signs. Both
were demolished to make way for four-storey townhouses and
apartments, called Portobello Harbour and Cois Eala (beside the
swans). Courtesy of Irish Free State Handbook, 1932.

Sole Free State Importers

MORRIS
CARS

A complete range is always
on view here. Immediate
delivery. Prices on request.
A trial run will gladly be
arranged for you.

Garage hours; 8 a.m. to 11 p.m.
including Sundays.

G. A. BRITTAIN LTD.

PORTOBELLO · DUBLIN

For Larkin there could only be one reply but he bided his time for five days and the
start of one of the busiest times of the year, the Dublin Horse Show at the RDS. At 10
a.m. the following Tuesday, trams around the city stopped and drivers and conductors
walked from them. Around 700 of the 1,700 employed by the company were involved.

The strike went on for a number of months with the workers gradually being
forced by circumstances to return to their jobs. But, while the employers claimed
victory, the ITGWU continued to recruit, and became the largest union in Dublin.
Larkin left Ireland and remained in America until 1923. William Martin Murphy died
in 1919.

THE GRAND CANAL

Canals were greatly encouraged by the Irish Parliament at the end of the eighteenth century, because overland transport was slow and expensive. Between 1730 and 1787, parliament provided upward of £800,000 for canal construction. It was also hoped that canals would act as a spur to industrialisation.

Strolling by the Grand Canal, Rathmines at end of the nineteenth century. A barge is visible, as it was one of the important forms of commercial transport until 1960. Even Guinness's Brewery used the canal to transport its kegs. Courtesy of IHPC/HXHS.

The Dublin United Tramways Company (1896), Ltd.

ROUTES	ROUTES.
NELSON'S PILLAR *to* DALKEY	NELSON'S PILLAR *to* HOWTH
to TERENURE	*to* SANDYMOUNT
to SANDYMOUNT	*to* DARTRY ROAD
to PALMERSTON PARK	*to* CLONSKEA
to RATHFARNHAM	*to* DOLPHIN'S BARN
to DRUMCONDRA	*to* GLASNEVIN
to DONNYBROOK	*to* HATCH STREET
to PHŒNIX PARK	*to* KINGSBRIDGE
to O'CONNELL BRIDGE	*to* INCHICORE
to PARKGATE	*to* WESTLAND ROW
to KENILWORTH SQUARE	*to* PARK GATE
to LANSDOWNE RD.	*to* BALLYBOUGH

THE NELSON PILLAR,
The centre of Dublin Tramway System.

Directors:
WM. M. MURPHY, J.P., Chairman.
Ald. W. F. COTTON, J.P., D.L., M.P.; JOSEPH MOONEY, J.P.;
CAPT. C. COLTHURST VESEY, D.L.
Secretary:
R. S. TRESILIAN, A.M.I.C.E.I., F.C.I.S.
Manager:
C. W. GORDON.

Offices: **9 UPPER SACKVILLE STREET, DUBLIN**

Route of the Dublin United Tramways Company, from Nelson's Pillar in O'Connell Street. Note the routes to Palmerston Park, Dartry Road and Kenilworth Square, via Rathmines. Also note the directors of the company, including William M. Murphy, who became infamous because of the 1913 Dublin Lockout. Courtesy of Howth Tram Museum.

The Newry Canal the first, begun in 1731, with the purpose of bringing coal from east Tyrone to Dublin. By 1803, the Grand Canal linked Dublin to Shannon Harbour, eighty miles away, a journey of eighteen hours. A chain of hotels was built along the route, including the Portobello Hotel. It was comparatively successful during its long existence. On the Grand Canal, boats drawn by horses carried around eighty passengers on a usually pleasant cruise with on-board catering. By 1906, there were

Commercial activity along the canal, 1903. Courtesy of OPW.

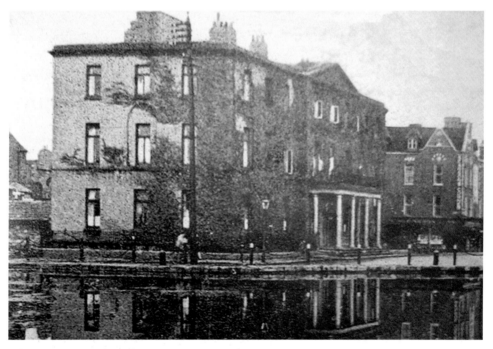

The Portobello Hotel, facing Rathmines and the Grand Canal, in the late nineteenth century. Courtesy of NLI/ DCL.

140 regular vessels plying the Grand Canal. The canal eventually passed to CIE, and later the OPW and Waterways Ireland. By the early 1960s, traffic had moved away from canals to coaches, railways, and ultimately motor vehicles. Recently, the Grand Canal has been improved for tourism and leisure activities.

LA TOUCHE BRIDGE

Portobello Bridge (officially called La Touche Bridge) is the Grand Canal bridge leading to and from Rathmines. If you live in Rathmines you will most likely walk across the bridge, either coming or going to An Lár. Built in 1791, it was named after William Digges La Touche, who was the director of the Grand Canal Company. Portobello, which means 'beautiful harbour', is the common name and it is very suitable for this handsome little structure.

Bicycles were of course one of the major forms of transport in Dublin, particularly before and after the Second World War, and right up until the 1960s, when the Grand Canal, the horse and dray, and the tram, were all overtaken by cars and buses. Still, the bicycle has not been abandoned, and in fact, since the new Millenium, it has enjoyed a new life.

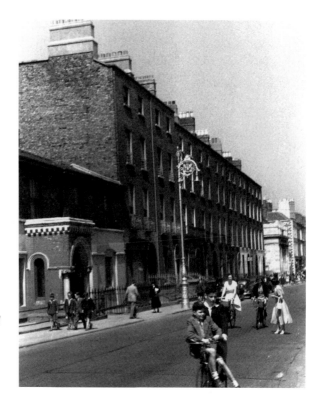

Left: *A boy gets a 'cross-bar' from a friend as they travel towards Portobello Bridge and Rathmines on a sunny day in the late 1950s.* Courtesy of RTÉ Stills Library.

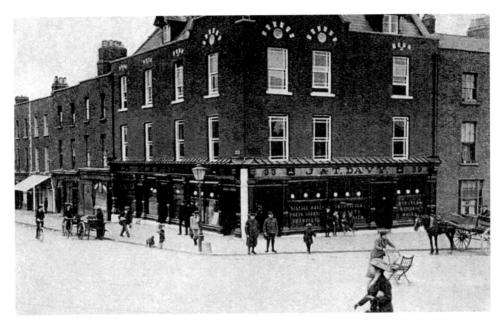

Leisurely scene around Davy's Pub at Portobello Bridge, facing away from Rathmines, at the end of the nineteenth century. Courtesy of IHPC.

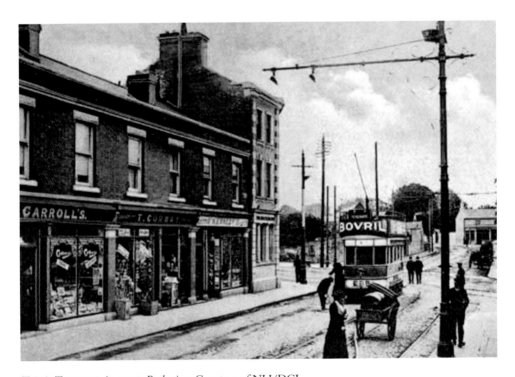

Tram in Terenure on its way to Rathmines. Courtesy of NLI/DCL.

8

An Abundance of Talent

Many famous names in the history of the art and literature of Ireland are associated with Rathmines. The Joyce family spent a significant part of their lives in the Rathmines area. John Stanislaus Joyce, originally from Cork, settled in Dublin, where he met Mary Jane Murray, while both of them were in the choir of the church of the Three Patrons, Rathgar. They married on 5 May 1880, in Our Lady of Refuge church, Rathmines. The family moved to 41 Brighton Square, Rathgar, where James Joyce was born on 2 February 1882. In 1884, the family moved to 23 Castlewood Avenue, Rathmines. *Ulysses*, written by James Joyce and published in Paris in 1922, is set in Dublin on 16 June 1904 (now known as Bloomsday), and there are many references in it to Rathmines and Portobello.

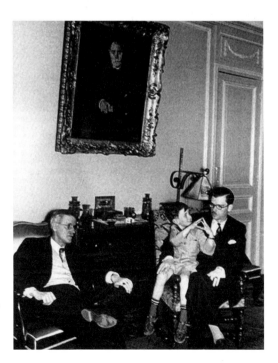

Generations of the Joyce family. James Joyce's
family life under a portrait of John Stanislaus Joyce,
including his son Stephen and brother Giorgio.
Courtesy of NLI/James Joyce Centre/
Rathmines Heritage Society.

Portrait of William Osborne by Walter Osborne. Walter Courtesy of National Art Gallery/HXHS/Rathmines Heritage Society.

ONE OF IRELAND'S MOST GIFTED ARTISTS

Walter Osborne (1859-1903) was born in Castlewood Avenue, Rathmines, the son of animal painter William Osborne. He studied at the Metropolitan School of Art in Dublin. Like many of the other artists, he moved to Continental Europe to study, spending time in France before moving to England in 1884. He mixed with many *avant-garde* artists of the day and was influenced by their treatment of light. He spent much time in England during the 1880s, where he painted rural scenes of villages with cottage gardens, just as he had done on the Continent. He returned to Ireland in the early 1890s, and continued to paint urban scenes and landscapes in the Dublin area. Walter Osborne is widely considered to be the only Irish artist who could be legitimately called an impressionist. During his short career he established himself as one of Ireland's most gifted artists. Sadly, he died of pneumonia in 1903 at the early age of forty-four.

ARTIST IS IRELAND'S FIRST OLYMPIC MEDALLIST

John 'Jack' Butler Yeats (29 August 1871-28 March 1957) was an Irish artist also associated with the area. He and his family lived at 14 Charleville Road in the 1880s (his father was also a well-known artist and his brother was poet William Butler Yeats). His early pictures are simple lyrical depictions of landscapes and figures, predominantly from the west of Ireland, especially of his boyhood home of Sligo. Yeats' works contain elements of Romanticism, and his favourite subjects included the Irish landscape, horses, circus and travelling players.

Unusually, Yeats holds the distinction of being Ireland's first medallist at the Olympic Games. At the 1924 Summer Olympics in Paris, his painting 'The Liffey Swim' won a silver medal in the arts and culture segment of the games. In the competition records the painting is simply entitled 'Swimming'.

Darrell Figgis, Irish patriot and activist in the War of Independence and prolific writer. Courtesy of NLI.

Jack B. Yeats' final drawing was done just days before he died in the Portobello Nursing Home at Portobello Bridge, overlooking Rathmines.

Æ IN GROSVENOR SQUARE

George William Russell (10 April 1867-17 July 1935), who wrote under the pseudonym Æ (sometimes written AE or A.E.), was an Irish nationalist, writer, editor, critic, poet, and painter. Born in Lurgan, County Armagh, his family moved to Dublin (Grosvenor Square) when he was eleven. He was educated at Rathmines School and the Metropolitan School of Art, where he began a lifelong friendship with William Butler Yeats. He started working as a draper's clerk, then worked many years for the Irish Agricultural Organisation Society (IAOS), an agricultural co-operative movement founded by Horace Plunkett in 1894.

From 1905 to 1923, Russell was editor from 1905-1923 of *The Irish Homestead*, the journal of the IAOS. His gifts as a writer and publicist gained him a wide influence in the cause of agricultural co-operation. He was also editor of the *The Irish Statesman* (1923-1930). The pseudonym Æ derived from an earlier 'Æ' on', signifying the lifelong quest of man.

His first book of poems, *Homeward: Songs by the Way* (1894), established him in what was known as the Irish Literary Revival, where Æ met the young James Joyce in 1902 and introduced him to other Irish literary figures, including W.B. Yeats. He appears as a character in the 'Scylla and Charybdis' episode *Ulysses*, where he dismisses Stephen's theories on Shakespeare. Russell died in 1935 and is buried in Mount Jerome Cemetery.

As we have read, the writers Annie M.P. Smithson and Dora Sigerson lived on Richmond Hill. Lafcadio Hearn, the great Irish writer of Japanese Haiku poetry and gothic writing is remembered with two plaques at Leinster Square and Prince Arthur Terrace, and, another one on Leeson Street.

Scientist and astronomer, Thomas Grubb is remembered by the place name, Observatory Lane, adjacent to the cricket club. He was a pioneer in making telescopes and he built some of the world's greatest, some of which are still in operation.

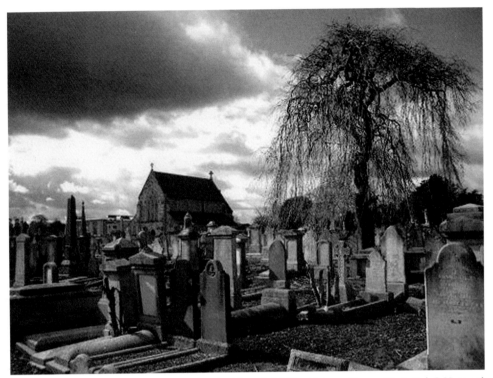

Mount Jerome Cemetery in Harold's Cross, where Lord Longford, Walter Osborne, Thomas Davis, Jack B. Yeats and George Russell (Æ) are buried. The Wilde family grave and the Guinness family vaults are also here. They were all former residents or had connections with the Rathmines area. Courtesy of Mount Jerome Cemetery.

The gravestone of Jack B. Yeats in Mount Jerome Cemetery, Harold's Cross. He had spent the last years of his life in Portobello House nursing home, adjacent to Rathmines. Brother of William Butler Yeats, Jack B. Yeats became an internationally renowned artist in his own right. Courtesy of Mount Jerome.

ANNIE MARY PATRICIA

Annie Mary Patricia Smithson (26 September 1873-21 February 1948) was an Irish novelist, poet and nationalist.She briefly practised in Ulster in 1901 before settling in Dublin as a district nurse. She converted to Catholicism in March 1907, and became a fervent republican and nationalist. She became a member of Cumann na mBan and campaigned for Sinn Féin in the 1918 General Election. She took the Republican side in the Irish Civil War and nursed participants in the siege at Moran's Hotel. In 1922, she was captured by Free State forces and was rescued from Mullingar Prison by Linda Kearns McWhinney and Muriel MacSwiney, posing as a Red Cross delegation. She was secretary and organiser of the Irish Nurses Organisation from 1929 to 1942. In 1917, she published her first novel, *Her Irish Heritage*, which became a bestseller. It was dedicated to those who died in the Easter Rising of 1916. The elaborately romantic plots of her highly popular novels – nineteen in all – were built on elements of her own experience, including a protracted and painful involvement with a married doctor. Her female heroes are strong and noble minded in novels such as *Carmen Cavanagh* (1921), *The Walk of a Queen* (1922), *The Laughter of Sorrow* (1925), *The Light of Other Days* (1933), and *The Weldons of Tibradden* (1940). Political loyalty to Ireland provides the main interest in books such as *Margaret of Fair Hill* (1939) and *By Shadowed Ways* (1943). *Myself and Others* (1944) is an autobiography. From 1932 onwards she shared a house in Rathmines with her stepsister and her stepsister's family. She died of heart failure at 12 Richmond Hill, Rathmines.

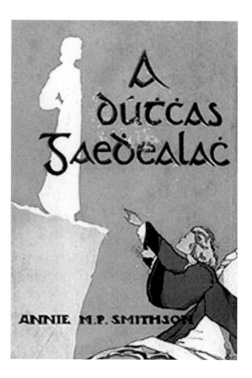

Annie Mary Patricia Smithson (26 September 1873-21 February 1948) was an Irish novelist, poet and nationalist. Courtesy of NLI/Rathmines Heritage Society.

The original Abbey Theatre. W.B. Yeats and Lady Augusta Gregory founded the Abbey Theatre in 1903. Its precursors were the Irish Literary Theatre and Frank and Willie Fay's National Dramatic Society. With patronage from Miss Annie Horniman, premises were purchased on Old Abbey Street, and on 27 December 1904, the Abbey Theatre opened its doors for the first time. The Fay Brothers lived at Ormond Road, Rathmines. Courtesy of the Abbey Theatre.

Rathmines Road, c. 1919. Courtesy of IHPC.

<p style="text-align:center">9</p>

On Stage and Screen

FROM THE PRINCESS TO THE SWAN

The Princess cinema in Rathmines was one of the first purpose-built picture houses in the country and opened on 24 March 1913, just a few months before the nearby Carnegie Library opened. It was originally called the Rathmines Picture Palace. The building was demolished in 1982. Interestingly, a Rathmines resident, James Joyce, set up the first Irish cinema, the Volta, located at Mary Street, Dublin. By the time another cinema, the Stella, opened in 1923, the township had been given supervision of cinemas in its area under the Censorship of Films Act. Three township censors had the task of passing or rejecting films shown in the area.

Both cinemas are now closed and Rathmines cinemagoers who harboured hopes that their beloved Stella cinema in Rathmines would one day reopen for business had their hopes dashed when a planning application lodged with Dublin City Council sought permission to construct a four-storey over-basement building with a pedestrian entrance on the site of the grand old cinema.

The Stella was called after the wife of Anthony O'Grady, the owner of Slattery's Pub (originally called O'Grady's) and later the Stella cinema itself. Generations of the O'Grady family ran the Stella for many years. It was eventually bought out by the Ward Anderson group, Ireland's largest cinema

Famous Abbey actor F.J. McCormick in Synge's the Playboy of the Western World, *in 1933. He lived at 16 Palmerston Gardens, Rathmines. Lennox Robinson called him the most versatile of all Abbey actors. He was also a film star of the 1940s and 1950s. He fell out with Sean O'Casey at the* Plough *riot when he addressed the audience, 'Don't blame the actors – we didn't write the play.' Courtesy of the Abbey Theatre.*

chain. They closed it down, planning to open a bigger cinema complex across the road in the Swan Centre. After the trials and tribulations of many planning applications they were eventually successful and opened a three-cinema complex in late 2009.

One man who has fond and very special memories of the Stella and her sister cinema further down the Rathmines Road, the Princess, is author George Kearns. George worked as an usher/doorman at the Princess and has written two books relating to Dublin cinemas – an *A to Z of All Old Dublin Cinemas* and *The Prinner*. 'The Stella's demise is imminent, just like that of the Princess,' Mr Kearns said in a newspaper interview with *Dublin People*. 'The Princess, although not a blood relation, became a sister to the Stella when their directors decided to merge together the two most popular cinemas in the Rathmines area.'

Reflecting on the sad demise of the two regal and much attended cinemas Mr Kearns said:

> The Princess, or 'Prinner' as most of her loyal subjects preferred to call her, took ill and closed on the night of 2 July 1960 as the Town Hall clock struck midnight and she never again played host to her patrons. She died in January of 1982 and her remains were laid to rest in a green field in Tallaght. Just like her sister, Stella took ill and closed her doors in the latter part of 2004 at the grand old age of 81 and for many years she rested and tried to regain her strength as her fans waited in vain for her recovery.

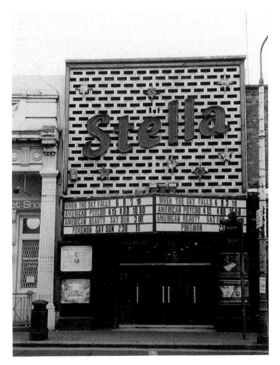

The famous Stella cinema in Rathmines. In later years, locals referred to it as 'the flea pit' ('go in crippled – come out walking'). The Stella was designed in a Classical style by the architectural firm Higginbotham & Stafford, and was located just to the south of Dublin city centre – not to be confused with the later Stella cinema (1955-1976) in the Mount Merion district. Courtesy of Dublin.ie/DCC.

Edward Pakenham, 6th Earl of Longford
(1902-1961), Irish nationalist (his Irish name was
Eamon de Longphort), playwright, translator, and
Irish politician. Between 1930 and 1936 he was
chairman of the Gate Theatre, Dublin. Between
November 1946 and 1948 Member of Seanad
Éireann (nominated by Taoiseach, Eamon de Valera)
One of Irish residences was at Grosvenor Park,
Leinster Road, Rathmines. (Also Tullynally Castle,
Longford). He died in Portobello Nursing Home.
Courtesy of HXHS.

Christine Longford (née Trew) married the 6th
Earl of Longford in 1925 and a year later moved
permanently to Ireland, where she and her husband
lived in Grosvenor Park, Leinster Road, Rathmines
during the week and Pakenham Hall, now Tullynally
Castle, at weekends. Both Longfords became deeply
involved in the Gate Theatre, Dublin. Christine
Longford wrote four novels between 1930 and
1935: Making Conversation, Country Places,
Jiggins of Jigginstown and Printed Cotton.
Edward Longford died in 1961 and Christine in
1980. Courtesy of DCC/HXHS/Rathmines
Heritage Society.

Alas, this is not to happen, and Mr Kearns has sadly acknowledged that any day soon the Stella is expected to succumb to her weakened condition and pass away in the same manner as the Princess. 'Fortunately, as a loyal doorman/usher to the beloved Princess, I have immortalised both her and her sister Stella forever,' he stated. 'My written record of the history of some old Dublin cinemas I have entitled *The Prinner*, in memory of my beloved Princess of Rathmines.

People associated with the theatre and film world and who lived in the Rathmines area include Hollywood actress Maureen O'Hara, the world famous film director Rex Ingram, and Bram Stoker's wife, who took legal action against German film pirates over the horror film *Nosferatu*, the famous vampire film that had been based on *Dracula*, the classic novel by her late husband. The Longfords of Gate Theatre fame lived on Leinster Road (Grosvenor Park).

FAMOUS REDHEADED ACTRESS WITH RATHMINES CONNECTIONS

Maureen O'Hara, (b.17 August 1920), the legendary Hollywood actress with Rathmines connections, celebrated her ninetieth birthday in Cork in 2010. Her autobiography, *Tis Herself*, was published in 2004. She is best known for her role as Mary Kate Danaher in the Oscar-winning *The Quiet Man* with John Wayne.

In her memoirs, Maureen Fitzsimons (to use her original name), recalls her father Charles Stewart Parnell Fitzsimons, as a decent, honest man, born to farming folk outside Kells. 'It was a country farm and many hands were needed to keep it running smoothly', she wrote. 'Daddy, when he was a young lad, was one of thirteen sons who helped his father work the land.' Her father's real passion was soccer. He played Gaelic football until he was caught at a soccer match once and he was kicked off the team, a victim of the infamous 'ban'. 'He later bought into Shamrock Rovers, and swore he would never go to another Gaelic football match again', O'Hara writes. 'He never did.'

Maureen O'Hara (born Maureen FitzSimons, 17 August 1920) is an Irish film actress and singer. The famously redheaded O'Hara has been noted for playing fiercely passionate heroines with a highly sensible attitude. She often worked with director John Ford and longtime friend John Wayne. Born in Ranelagh. From the age of six to seventeen, she trained in drama, music and dance. At the age of ten she joined the Rathmines Theatre Company and worked in amateur theatre in the evenings, after her lessons. Courtesy of RHS/HXHS.

Charlie Fitzsimons married Dublin girl Marguerita Lilburn and they moved into a six-bedroom house in Ranelagh. There, their six children were born. Maureen was the second oldest. She went to elocution and drama school, and singing and dancing classes. When she was ten, she joined the Rathmines Theatre Company. She began winning amateur acting competitions and feis events, and at the age of thirteen was hired to perform classical plays on Raidió Éireann. In 1934, she joined the Abbey,

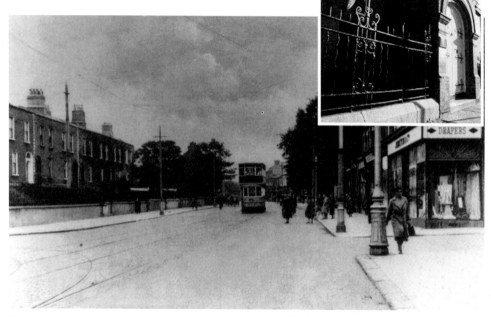

The original YMCA building on corner of Rathmines Road and Grove Road. Built in 1911, it is now home to the Leeson Park School of Music. It has a very ornate front entrance. The YMCA was practically built with a donation of £3,000 from a Mrs Maria Duckett, one of the last of the big ascendancy families in Ireland and part of the Carlow gentry. By the middle of the nineteenth-century, the Duckett estate spread across five counties. Courtesy of Duckett's Grove/LPSM.

Ranelagh in the early 1950s. In ancient times, four roads led into Dublin from the south-west. What is now Rathmines and Ranelagh was a dangerous no-man's land between the walled city and the Wicklow Mountains. Many a bloody battle was fought there between the native Irish, banished to the mountains, and the foreigners who has usurped their lands. The famous Battle of Rathmines between Cromwellian forces and Royalists was fought where now stand some of the finest late Georgian and Victorian streets. Fear of the mountain enemy inhibited suburban settlement until the mid-eighteenth century, when the tiny villages of Rathmines, Cullenswood and Ranelagh began to develop. In 1847, Rathmines Township was formed, and for the next century, intense development created one of the most attractive and exciting areas, socially and architecturally, in Dublin. Though originally a strongly unionist area, it was also home to many Fenians and Young Irelanders. Four of the signatories of the 1916 Proclamation, among them Patrick Pearse, marched out from Ranelagh on that historic Easter Monday, never to return. Courtesy of Ranelagh Village.

starting at the bottom of the ladder, painting scenery, building sets and sweeping floors, and eventually three years later was cast in a lead role.

She never got to play her lead role, however, as she was spotted by American singer Harry Richman, who brought her to London and introduced her to Charles Laughton, who, having seen her in a screen test, immediately signed her up with Mayflower Pictures on a seven-year contract. It was the start of a film career that was to see her become one of Hollywood's greatest stars.

An icon of Hollywood's Golden Age, at the height of her career O'Hara was considered one of the world's most beautiful women. She is often remembered for her on-screen chemistry with John Wayne. They made five films together between 1948 and 1972: *Rio Grande*, *The Quiet Man*, *The Wings of Eagles*, *McLintock!* and *Big Jake*.

THE WORLD'S GREATEST FILM DIRECTOR

Rex Ingram (1892-1950) was a film director, producer, writer and actor. Legendary director Erich von Stroheim once called him 'the world's greatest director'. The son of a clergyman, he was born Reginald Ingram Montgomery Hitchcock and was educated at St Columba's College, near Rathfarnam. He spent most of his adolescent life living in the Old Rectory, Kinnity, Birr, County Offaly, where his father was the Church of Ireland rector. The family then moved to Grosvenor Square, Rathmines. He emigrated to the United States in 1911.

Ingram studied sculpture at the Yale University School of Art, but soon moved into film. His first work as producer-director was in 1916 on the romantic drama *The Great Problem*. He worked for Edison Studios, Fox Film Corporation, Vitagraph Studios, and then MGM, directing mainly action or supernatural films. In 1920, he moved to Metro, where he was under supervision of executive June Mathis. Mathis and Ingram would go on to make four films together, *Hearts are Trump*, *The Four Horsemen of the Apocalypse*, *The Conquering Power*, and *Turn to the Right*. It is believed the two were romantically involved. Ingram and Mathis had begun to grow distant when her new find, Rudolph Valentino (who later became a Hollywood heartthrob and legend), began to overshadow his own fame. Their relationship ended when Ingram eloped with Alice Terry in 1921. She had starred with Rudolf Valentino in Ingram's classic film *The Four Horsemen of the Apocalypse*.

Ingram married twice, first to actress Doris Pawn in 1917. This ended in divorce in 1920. He then married Alice Terry in 1921, with whom he remained for the rest of his life. In 1925, Ingram and Fred Niblo directed the hugely successful epic *Ben Hur*. He and his wife decided to move to the French Riviera. They formed a small studio in Nice and made several films on location in North Africa, Spain, and Italy for MGM and others.

Side view of Holy Trinity church, Rathmines, c. 1955. Courtesy of IHPC.

Early photo of Rex Ingram. Courtesy of Rathmines Heritage Society.

Amongst those who worked for Ingram at MGM on the Riviera during this period was the young Michael Powell, who later went on to direct (with Emeric Pressburger) *The Red Shoes* and other classics. By Powell's own account, Ingram was a major influence on him. David Lean also admitted he was deeply indebted to Ingram. Rex Ingram's films were considered by many contemporary directors to be artistic and skilful, with an imaginative and bold visual style. In 1949, the Directors Guild of America bestowed an Honorary Life Membership on him and he also has a star on the Hollywood Walk of Fame.

Hollywood greats Rudolf Valentino and Alice Terry in Rex Ingram's early 1920s film Four Horsemen of the Apocalypse.

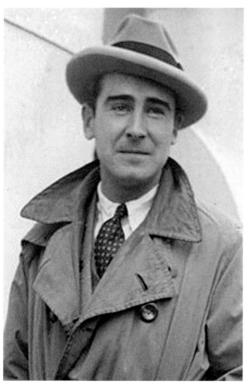

Rex Ingram (15 January 1892-21 July 1950).
Courtesy of Rathmines Heritage Society.

Plaque on the exterior of No.58 Grosvenor Square, where world-famous film director Rex Ingram lived. Courtesy of Dublin Tourism/Fáilte Ireland.

OSCAR WILDE'S GIRLFRIEND AND DRACULA

Florence Balcombe (1858-1937) was the wife of Bram Stoker, whom she married in 1878. She spent her formative years living at 66 Palmerston Road, Rathmines. She was a celebrated beauty whose former suitor was Oscar Wilde. Bram Stoker had known Wilde from his student days in Trinity College, having proposed him for membership of the university's philosophical society while he was president. Wilde was upset at Florence's marriage, but Stoker later resumed the acquaintanceship.

The Stokers moved to London, where Stoker became acting-manager and then business manager of Henry Irving's Lyceum Theatre, London, a post he held for twenty-seven years. On 31 December 1879, their only child was born, a son that they christened Irving Noel Thornley Stoker.

Florence Balcombe was responsible for the destruction of most of the prints of the 1922 horror film *Nosferatu*, which was based without attribution or permission on Stoker's novel *Dracula*. Her attention was drawn to the issue by an anonymous letter from Berlin.

Balcombe was struggling financially and, as Stoker's literary executor, had never given permission for the adaptation, nor received payment for it. Her furious response to this copyright infringement was prompt and uncompromising; not only did she want the financial reparation she felt was due to the estate, she demanded that the negative and all prints of the film (which she would never actually see) be immediately destroyed.

Balcombe launched a lawsuit which took some time to resolve; at one point, the German production company Prana-Film declared bankruptcy to avoid paying for the adaptation. Finally, she won the case, with the final ruling in July 1925 stating that the negatives and all prints of the film should be handed over to her to be destroyed.

From the early 1920s German film Nosferatu.
*Bram Stoker's wife Florence sued over the
making of this film, claiming (successfully) that
it was based on her husband's film* Dracula.
Courtesy of HXHS/Rathmines Heritage
Society.

THE R&R

It all started in 1913, at a meeting held in 48 Summerville Park, Rathmines. C.P.
Fitzgerald, who was the young organist at that time in Rathgar's church of the Three
Patrons, wanted to establish a musical society whose membership would be formed
from residents of the Dublin townships of Rathmines and Rathgar. The objectives of
the proposed musical society were the study of, and production of, operatic, choral and
other high-class musical works. Notwithstanding the passing of the years, and even
into the twenty-first century, the society remains faithful to its original objective.

While the production team, orchestra and technical crews (including lighting and
set design) for each of the society's productions is provided by experienced theatrical
professionals, the chorus members and principal line-up that appear on stage remains
amateur. This ethos is guarded by the society's voluntary executive committee, which is
made up of representatives of all the elements of the society's interest groups, associate
members and corporate supporters.

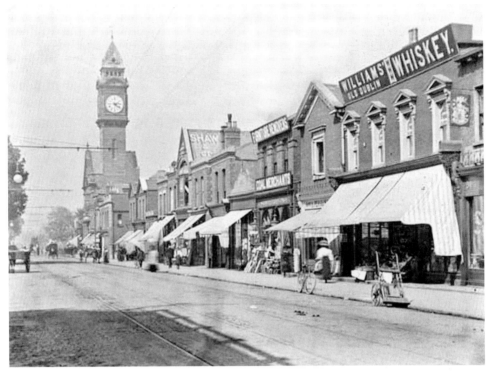

Rathmines Road, c.1925. Courtesy of IHPC.

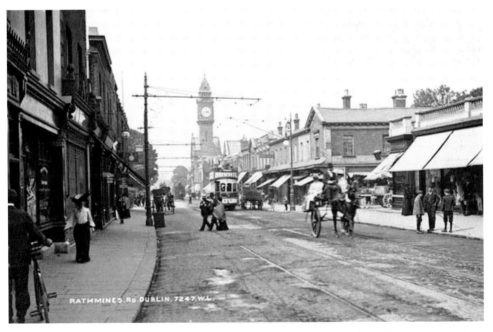

Rathmines, c.1912. Besides the Terenure tram, the main forms of transport were horse-drawn drays, carts and carriages. Courtesy of NLI.

The first production – Gilbert and Sullivan's *The Mikado* – was staged by the R&R in the Queen's Theatre, Pearse Street, in December 1913. The following year, also in December, the society performed for the first time in the Gaiety Theatre, with another Gilbert and Sullivan operetta, *The Yeomen of the Guard*. As the society developed and membership expanded, it was decided to complement the society's Gilbert and Sullivan performances by including other musical comedy productions in its repertoire. In 1915, Planquette's *Les Cloches de Corneville* was performed and, this broadening of the society's range of productions, afforded its members many different opportunities to use their individual and combined range of musical talents and dramatic skills.

The society has, since its establishment nearly 100 years ago, become a major contributor to the musical theatre life of Dublin City. The twice-yearly productions, professionally presented in prestigious locations (including the National Concert Hall) continue to attract maximum audiences.

The Outdoor Life

There is much open space devoted to outdoor pursuits in the Rathmines area. The district is blessed with parks and playgrounds. Moreover, some of the sporting endeavours have been greeted with great acclaim. The St Mary's rugby team has provided the national team with some great players. The Leinster Cricket Club is one of the oldest in the world. The Kenilworth Bowling Club at Grosvenor Square has a very interesting history, being associated with the Eason's family of bookshop fame. The Stratford Lawn Tennis Club in Grosvenor Square competes with St Louis School for the attention of budding tennis aces.

Children pose, watched by family members, in Palmerston Park at the end of the nineteenth century. Palmerston Park was the headquarters of James Butler, 1st Duke of Ormonde, during the Battle of Rathmines in 1649. Today Palmerston Park is a secluded, peaceful place in which Dublin's southsiders are free to wander and relax. Its semicircular shape gives the impression that the park is very small, but take a walk through and you'll be surprised. Courtesy of IHPC.

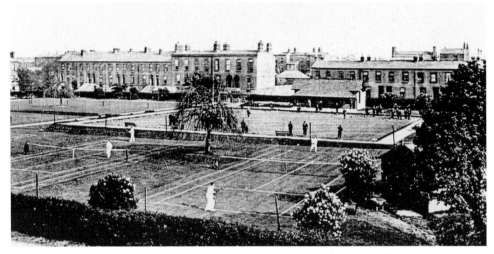

Playing tennis at Grosvenor Square at the Stratford Lawn Tennis Club in the late 1940s. Behind, the Kenilworth Bowling Club members are in action. In 1892, a group of influential 'upper-class' gentlemen got together and decided to form a bowling club in Dublin. This meeting took place at either No.29 or 30 Kenilworth Square, both the property of Mr Charles Eason (of Eason's book stores fame) and the first woods were rolled on the rear lawn. At that time the club played at Kenilworth Square and the first prizes for competitions were two woods, dated 1893 and 1894, both won by a Mr W.W. Eason in singles play. Kenilworth Square proved not to be an ideal venue for bowls, and so in 1909 it was decided to lease the entire lands at Grosvenor Square and lay a proper green. Then, in 1922, they purchased the freehold at a cost of £485. Courtesy of IHPC.

ST MARY'S RFC

It was in September 1900, at St Mary's College Rathmines (with which it has always kept a close relationship) that the club was formed and it was then known as Old St Mary's FC. It later became St Mary's College RFC. It was to be an open club, playing open rugby, a tradition retained and cherished to this day. In the early days, the matches were played in the front field at the college and the first trophy, the Leinster Junior Cup was won in 1905. For many years they trained at Kimmage Grove, near Harold's Cross. They were very lucky to secure this ground, which they ended up renting from a farmer, Mrs Doherty, for over twenty years, until the farm was sold in 1954 (later to become College Park Estate). During the happy tenure there, the club won many junior cups and learned the best side steps in Dublin rugby, when avoiding the sheep and cattle dung (the pitches being also leased for grazing farm animals).

In 1955, a wonderful new clubhouse and grounds were opened on College Drive (off Fortfield Road) and so began a golden era in St Mary's history. It took only a few years to taste success, for in the 1957/58 season, under the captaincy of Joe Fanagan and with wonderful players like Ned Carmody, Vincent McGovern, Sean Cooke, Jack Bagnall, the Hussey twins, Dick Whitty, Ken Wall and Nicky Corrigan, they brought home the Leinster Senior Cup for the first time. The LSC at that time was the most prestigious trophy in Irish rugby, and the most difficult to win.

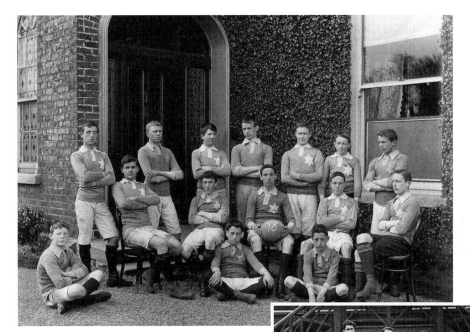

St Mary's College, SCT rugby team, 1898. St Mary's College C.S.Sp. (Congregatio Sancti Spiritus) is an all-boys' primary and secondary school run by the Congregation of the Holy Spirit and located in Rathmines. The school was founded in 1890. Rugby is the major sport and the school colours are blue and white. St Mary's have produced thirty-one schools' international players since 1975 – more than almost any other school – as well as several full international players, such as Denis Hickie, Jonathan Sexton and Seamus Deering. The school has won the Leinster Schools Senior Cup five times and is considered one of the top rugby-playing schools in Leinster. Past pupils created the associated club – St Mary's College RFC. Notable alumni include Irish patriot Kevin Barry, broadcaster Larry Gogan, Tom O'Higgins, former Chief Justice of the Irish Supreme Court and many more. Courtesy of St Mary's College.

Early twentieth-century picture of a St Mary's school rugby team. St Mary's College RFC was established in 1900 as 'Old St Mary's'. Courtesy of St Mary's College, Rathmines.

The sixties saw a stream of cups come home to St Mary's at junior level, and then, in 1969, having been so close on a few occasions, the great Sean Lynch (who afterwards was to be our first international and British and Irish Lion) drove his super team to win the LSC again. During the sixties, the club had many provincially capped players and it was growing in strength and status all the time. The cup was to be won again in '71, '74, '75, '87, '93, '95, 2005 and 2010. St Mary's won the IRFU centenary All-Ireland C in 1975, led by the wonderful Johnny Moloney.

The seventies was the glorious age, with many trophies at all levels being won and with wonderful players like Sean Lynch, Dennis Hickie, John Moloney, Tom Grace, Seamus Deering, Tom Feighery, Tony Ward, Terry Kennedy, Ciaran Fitzgerald and Rodney O'Donnell all being capped for Ireland. Of course, Johnny Moloney, Tom Grace and superhero Seamus Deering captained Ireland during that period, and later Ciaran Fitzgerald captained Ireland to a Triple Crown in '82 and '85, and captained the Lions in 1983.

The club can boast ten Lions, twenty-six full internationals, three club internationals and over 120 inter-provincial players stretching back to 1911, as well as several A inter-provincial, A international, underage international and colleges international players. St Mary's College RFC has won over 100 LB/IRFU trophies.

THE LEINSTER CC

A genteel pastime of French origin was the temporary craze in those lazy days of the mid-1800s. Dublin's aristocrats and those not-so-aristocratic, the young and old, men and women, disported themselves at bal-ballon. For some, though, the sport was not quite energetic enough. It did not altogether suit the volatile temperament. An alternative was sought.

'Some of the Young Blades of the time did not consider the game spirited enough and decided to try their hand at cricket', wrote the legendary Bob Lambert when reminiscing about the birth of a club of which he was to become the most celebrated member. 'Only a few isolated matches had been played, but once the Rathmines boys became interested, cricket's popularity was assured', he recalled in later years, with tongue in cheek.

So the Leinster Cricket Club came into being on 1 May 1852. According to the original minute book preserved in John Lawrence's Handbook of 1865, 'twenty-five names were immediately enrolled as original members'. The first match was played on 29 June 1852 against Roebuck, who scored 52 and 44 to Leinster's 62 and 24, and the first victory was not recorded until September, when in the very last match of the season, Kingstown were defeated 'amid scenes of wild jubilation and celebration'.

(Murrough MacDevitt, Celebrating 150 Years of the
Leinster Cricket Club. *Dublin, 2002)*

The club in those early tentative years wandered about Rathmines, from Grosvenor Square, its original ground, to Rathgar, opposite the end of Garville Avenue, in 1853. The following year it moved again, this time to the vicinity of Palmerstown Park where it remained until 1861. The next move was to Emor Ville, opposite Portobello Gardens, on the South Circular Road, before finally coming to roost in the present location in 1865.

Lawrence's *Handbook* relates that one A.J. Mahon:

…came forward and purchased a splendid piece of ground expressly for the purpose of securing its possession for his club, generously giving them a year's time to determine whether they would become owners themselves or rent it from him at £60 a year.

Leinster-like, they wisely determined on complete independence, and the result of the appeal from the committee to the club is shown in the list of subscribers, thereby securing the possession of as fine and conveniently circumstanced a piece of ground as could possibly be hoped for.

The ground is held under lease for the lives of His Royal Highness, the Prince of Wales, H.R.H. the Princess of Prussia, and Prince Alfred, Duke of Edinburgh. The Proprietors receive five per cent of their money, the capital being secured by assurance, the total charge against the club funds being about £40 annually.

The appeal to club members for funds to help buy the ground raised the necessary £400, a huge sum in those days.

At Observatory Lane, Leinster grew from strength to strength and before long held a prominent position in the expanding cricket circle of sports-conscious Dublin. With a home of their own, the future was now secure.

A COLOSSUS AND TITAN OF SPORT

And lest we forget that titan among batsmen, a colossus of the sport's arena, the greatest Irish cricketer of all time, Bob Lambert, who first played on the Leinster senior team at the age of fifteen. Two years later he won his place on the international XI, which he was to captain for three decades. One newspaper reported:

A hit which will live in memory was that made by Bob against County Kildare as far back as 1904. These were the days when the Short Grass county could put a really strong team in the field. W.H. Harrington and W. Keyes were then at their best, and Lambert hit Harrington onto the roof of a house on the far side of Mountpleasant Avenue – a hit never claimed before or since.

Bob Lambert will always be remembered and indeed revered in Irish cricket. Asked by a cricket correspondent if Lambert would have been an even greater cricketer had he played regularly in England, W.G. Grace replied: "How do you improve on perfection!" How indeed.

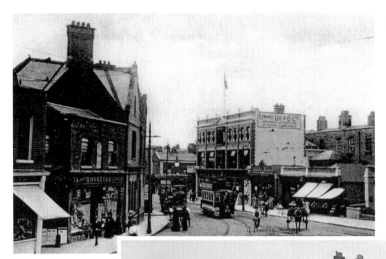

Junction of Rathmines Road, c.1910, with the famous Lee's Department Store in the centre. Lee's stayed in business in the area right up until the early 1970s. Courtesy of IHPC.

Kenilworth Bowling Club in Grosvenor Square, c.1912. the club formed in 1892 and derives its name from its first home, nearby in Kenilworth Square. Courtesy of IHPC.

KENILWORTH BOWLING CLUB

It can be said the modern game of bowls started at the end of the nineteenth century, but for hundreds of years Dublin citizens have played the game on public and private greens. The Marlborough Street gardens, which have been traced back to the twelfth century, developed gradually from a bowling green into a pleasure garden. As the *Hibernian Journal* of 15 October 1703 reported, 'The new Bowling Green in Gt Marlborough Street has also a handsome house with two Billiard tables, Card House with Card tables, and a house to shelter the gentlemen when raining.' In 1761, their existence came to a definitive end, owing to a row over a woman, which resulted in the duel in which the heir of the Earl of Westmeath was killed.

EXERCISING AFTER THE FATIGUES OF STUDY

The oldest Dublin bowling green was to be found on Hoggen Green, of which College Green formed a part. Over three centuries ago, the city authorities made an order that, 'Robert Taylor should be allowed to make what profit and benefit he can of

the free use and exercise of bowling, and that he shall have charge and care of looking after and overseeing the said un-railed bowling place in Hoggen Green during our pleasure.' However, buildings were springing up over the southern part of the Green and when St Andrew's church was demolished on Dame Street, it was decided to re-erect the church on the bowling green of Hoggen Green. This took place in 1670. There is also a record of a bowling green in Trinity College, 'for the exercise of the students after the fatigues of their studies'.

There was another bowling green in Chapelizod, run by the Victoria Bowling Club. Here, play was restricted to two days a week, Tuesdays and Fridays, on which days transport for members was provided from Essex Quay to the green at Chapelizod.

FROM BOOKS TO BOWLING

In the first part of the nineteenth century, there is no record of any bowls being played. In 1892, a group of influential 'upper-class' gentlemen got together and decided to form a bowling club in Dublin. This meeting took place at either No.29 or No.30 Kenilworth Square, both the property of Mr Charles Eason (of Eason's Bookshops), and the first woods were rolled on the rear lawn. The first members appear to have been prosperous businessmen and included several of English and Scottish origin. This group formed Kenilworth Bowling Club.

At that time the club played at Kenilworth Square and the first prizes for competitions were two woods, dated 1893 and 1894, both won by a Mr W.W. Eason in singles play. It appears that the membership was quite elite, and came from a high social standing, as its early patrons were the chief figures in government: the Earl of Aberdeen, who was then Lord Lieutenant for Ireland, and the Honourable H.W. Long, the Chief Secretary. In line with the social status of the members, its first annual ball was held in the Town Hall in 1906. This must have been an elaborate event, with double tickets costing 15s and single tickets 10s. Kenilworth Square proved not to be an ideal venue for bowls, as during the winter months the green was used for football and other winter sports, so in 1909 a limited company was formed and the directors decided to lease the entire lands at Grosvenor Square and lay a proper green. Then, in 1922, they purchased the freehold at a cost of £485.

The original founder member clubs of the Bowling League of Ireland were: Kenilworth, Railway Union, Leinster, Blackrock and Clontarf. Kenilworth Club was formed in 1892, Railway Union in 1904, Blackrock in 1906, Leinster in 1913 and Clontarf in 1925. On 25 March 1927, Mr W. Clarke of Kenilworth, arranged a meeting with the above clubs and it was proposed that an association to control the game in the Republic be formed. And so the Bowling League of Ireland (BLI) was born.

The first municipal bowling green was laid in Herbert Park in 1944. CYM Club in Terenure was formed one year later. Kenilworth laid a second green in 1993 and is now the only club in the BLI to have two greens. Stratford Lawn Tennis Club shares the Grosvenor Square grounds with Kenilworth.

Further Reading

F.E. Ball, *A History of the County Dublin*, 5 Volumes (Dublin, 1902-1917).

F.E. Ball, *The Battle of Rathmines* (Dublin, 1902).

Maurice Curtis, *A Challenge to Democracy* (Dublin, 2010).

Maurice Curtis, *The Splendid Cause* (Dublin, 2008).

Maurice Curtis, *Harold's Cross* (Dublin, 2005).

Maurice Curtis, *A Short History of Ireland* (Dublin, 2003)

Mary E. Daly, *Dublin's Victorian Houses* (Dublin, 1998).

N. Donnelly, *A Short History of the Parishes of Dublin* (Dublin, 1900).

J.T. Gilbert, *A History of the City of Dublin*, 3 Volumes (Dublin, 1861).

William Domville Handcock, *The History and Antiquities of Tallaght in the County of Dublin*, 2nd Edition (Dublin, 1899).

Weston St John Joyce, *The Neighbourhood of Dublin* (Dublin, 1921).

Ray Kavanagh, *Mamie Cadden: Backstreet Abortionist* (Cork, 2005).

George, P. Kearns, *The Prinner: The Story of the Princess Cinema, Rathmines and Other Dublin Picture Palaces* (Dublin, 2005).

Deirdre Kelly, *Four Roads: The History of Rathmines, Ranelagh and Leeson Street* (Dublin, 2001).

G.A. Hayes-McCoy, *Irish Battles: A Military History of Ireland* (Dublin, 1998).

Murrough MacDevitt, *Centenary Book of the Leinster Cricket Club* (Dublin, 2002).

Eamonn MacThomáis, *Me Jewel and Darling Dublin*, 20th Anniversary Edition (Dublin, 1998).

Anne Marreco, *The Rebel Countess: The Life and Times of Constance Markievicz* (New York, 2002).

Séamas O'Maitiú, *Dublin's Suburban Towns 1834-1930* (Dublin, 2003).

Rathmines Heritage Society, *Rathmines Through the Ages* (2008).

Rathmines Pastoral Council, *Rathmines Church 1856-2006: A Journey of Faith* (2007).